I Still Do

To my husband, Edmund Ackell. With deep love, respect, and gratitude.

This book is also dedicated to the women and men who care for family members with Alzheimer's Disease.

pH powerHouse Books Brooklyn, NY

I Still Do by Judith Fox

Loving and Living with Alzheimer's

Foreword by Roy L. Flukinger

"Who are you?" said the Caterpillar.

This was not an encouraging opening for a conversation. Alice replied, rather shyly, "I——I hardly know, sir, just at present—at least I know who I was when I got up this morning, but I think I must have been changed several times since then."

Lewis Carroll, *Alice's Adventures in Wonderland*

More than five million Americans have Alzheimer's Disease. That's the statistic. It's sad and scary, but ultimately just a number until you or someone you love is tormented by the disease. Then your life changes forever.

My life was upended in 1998 when my husband, Ed, was diagnosed with Alzheimer's. We had been married for three years. I was recently widowed and he was divorced when I fell in love with this accomplished man who ate the right foods, exercised, and completed his crossword puzzles in ink. There was no history of the disease in Ed's family, but Alzheimer's doesn't play favorites and it doesn't play fair.

The future, as we had planned it, wasn't going to happen. For a couple of years after receiving Ed's diagnosis, we evaded reality and denied growing evidence of the illness. It was true that Ed had trouble with his memory. He didn't track conversations the way he used to and he was sometimes uncharacteristically irritable. At the same time, he also avidly read his medical journals, became an active partner in a start-up business, and played tournament golf—amazingly sinking his third and fourth holes-in-one.

Searching for answers, I bought a stack of books on Alzheimer's. It took me two years to open the first one.

During this period, I was actively involved in making, exhibiting, and selling fine art photographs. I focused my eyes and my camera on strangers and, occasionally, took superficial snapshots of the man I love. I've always seen things more clearly through my camera lens, and I wasn't ready to confront—to literally zoom in on—what was happening to Ed.

Eventually, the dancing and the denial stopped. I began making photographs of my husband, my friend, my lover, and muse.

I photograph Ed to remember him, to celebrate him, and to keep him close as he's leaving.

Judith Fox

BEYOND THE MIRROR

In a brilliant essay that he penned some twenty years after photography's public emergence, Oliver Wendell Holmes dubbed the medium "the mirror with a memory." Although he was writing in 1859 about the daguerreotype—a process with a highly reflective, shining-silver coating—Holmes' simple phrase conveyed so much more. The meaning was amplified to include all photographic processes of the day and transferred into the popular culture, going beyond physical descriptiveness to convey far deeper philosophical, social, and personal depths. The leap to extending this metaphor to all photography was at once both direct and deeply profound. Utilizing the natural light of the sun, early photography was known, appreciated, and indeed, treasured for its power to delineate and preserve with profound accuracy the features of each human face. In the process of looking and seeing, each viewer could, by quick and natural extension, also come to believe and feel that this same "mirror" could, just perhaps, reveal aspects of each person's character and life experience as well—certainly in the case of those subjects that we knew and/or loved.

Today—right now—nearly all of us who have a camera in our hand, whether it be the finest precision instrument or merely a feature of our cellular telephone, are engaged in this process in some immediate fashion. The intent of the photographer is to create the image, but that is only the first half of a far larger equation. In order for the process to be completed, the image must have a viewer and must utilize some tangible form of production or transmission in order to experience the thoughts and feelings that the photographer intends to share with others.

It is this profound impetus and immediacy of sharing that marks the certain rise of thoughtful and compassionate photographers from among the vast crowd of general image-makers. They are the ones who continue to see most clearly, to be moved most deeply, and to be driven to apportion to all us potential viewers the opportunity to experience, feel, and learn from what they have seen and felt. They are the ones who do not take the photograph for granted, in much the same fashion as Holmes admonished us all not to take the sun for granted in the course of each day.

Judith Fox does not take life for granted. I doubt that she ever did, for artistry of her level is experienced and not just learned. And she certainly has focused upon it passionately during

the last decade. For in the course of these past few years, she has had to come face-to-face with one of our modern era's most devastating diseases—Alzheimer's—and its incessant and insidious impact upon her husband, Edmund Ackell. It is a tragic and undeserved infirmity—and one that impacts millions of sufferers, their families, and friends every year. It is an ugly, unfair, and achingly progressive illness, seemingly bestowed by an unfeeling fate. While one's body can remain intact, Alzheimer's steals our memories, distorts our personality, disrupts our emotional stability—in short it transforms our individuality and all of those qualities that have made each of us unique from the day of our birth. And that can be terrifying. As Elie Wiesel once observed: "If there is a single theme that dominates all my writing, all my obsessions, it is that of memory—because I fear forgetfulness as much as hatred and death." Alzheimer's disease changes our known life and unearths a buried and formerly unknown self. It places all who are affected by it into a meaner, unfamiliar reality. And for now it is incurable.

Ed presses onward—there is no past tense here for so dynamic a human being—his body and spirit still with us even as his mind and memories are under siege. And, as the photographs and words in this book will attest, Judith stays on right by his side, even as their lives are fragmented by their shared battle with Alzheimer's. I am impressed by the depth and range of their love and the courage with which they face each day in this campaign.

In one sense, Judith and Ed's story is not unique; unfortunately Alzheimer's is so all-pervasive a disease that their story only reinforces the universality of our shared humanity. However, Judith's photographs, done in true collaboration with Ed, do go far beyond these tragic circumstances. In the first place they are, of course, records of their lives, and like most good photo-documentary work, they provide us with the tangible evidence of their daily experiences. Like any solid photojournalist Judith provides us with a complete perspective, taking us in for the close up, back for the wider perspective, around for the sense of environment, and intimately forward for the detail of Ed's hands, eyes, and, at times, his lovely soul. And then finally tying it all together with her elegant and moving words.

But that is far from all that she does. Her mirror is constantly searching for the memory also. Memory—as Socrates reminded Plato—is the mother of the Muses, and Judith certainly has proven her affinity to these wellsprings of creativity. Her camera records not just faces and places, but moments, expressions, relationships, gestures, and meanings as well. The art of the photograph—an art she continues to feel so deeply—is that it can capture the emotion as

well as the form. This is the consummate quality that great photography can attain, as writers and artists both before and after Holmes have continued to show us all. The essayist was certainly no stranger to human mortality—he taught anatomy and physiology at Harvard—but Holmes always advocated the unyielding quest to search out and find that immortal soul that, as he reminds the remainder of us mortals, lies behind each face and form as well.

Indeed, Judith Fox knows—unerringly and truthfully—what Anne Lamott has always bid us to be mindful of: in order for art to be great, it has to point somewhere. Of the millions of photographs that families take of their loved ones who face this unkind fate, how many are capable of completing the equation and transmitting their feelings of loss and fear and despair in the way that Judith's images do time and time again? Photographers return from battlefields and natural disasters with images of casualties and destruction often. But how many of them take us beyond and through the physical destruction and have us feel the devastation to the heart and soul as well? In sharing Ed's plight through Judith's photographs, we come to realize what Mary David Fisher found through her own struggle with HIV/AIDS: that "the length of our life is less important than its depth." Just perhaps—if Judith's imagery makes us want to hug our family members a little more tightly or call up old friends and see them more frequently as the years tear by—the transcendent power of the photograph itself can be truly realized.

Such is the power of Judith's view into Ed's heart as well as her own. And, despite time's too swift course through all our days, she continues to provide us with the genuine possibility and strength to be transformed for the better by her photographs and her passion to share them with us all.

The sad fact is that despite the power of the mirror with a memory, memories themselves do not last forever. They are as finite and as mortal as we are. But the infinite capacity of the human heart—now, that *can* make it through all eternity. And somewhere in between falls the photograph.

Roy L. Flukinger
Senior Research Curator
Photography Department, Harry Ransom Center
The University of Texas at Austin

These are some of the things my husband used to do:
fly a plane, perform surgery, consult worldwide,
head a university and medical centers, hit four holes-in-one,
and play on the same basketball team as Bob Cousy.

These are some of the things my husband can't do anymore:
find his way to and from an unfamiliar bathroom,
work the coffee maker, play tournament golf,
or remember something I told him two minutes ago.

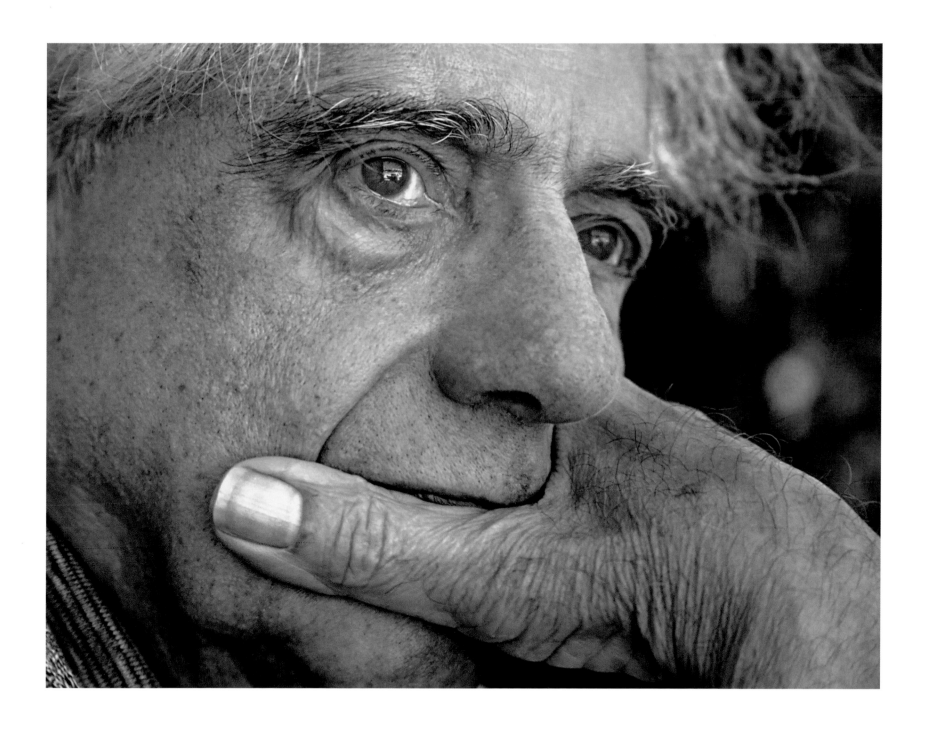

These are some of the things my husband can do:
express his love and appreciation,
explain a medical issue to a lay person in such a way that they understand it,
remember his best friend from childhood who was killed at Normandy,
answer some of my math questions,
supply words I can't recall, shave, and shower.

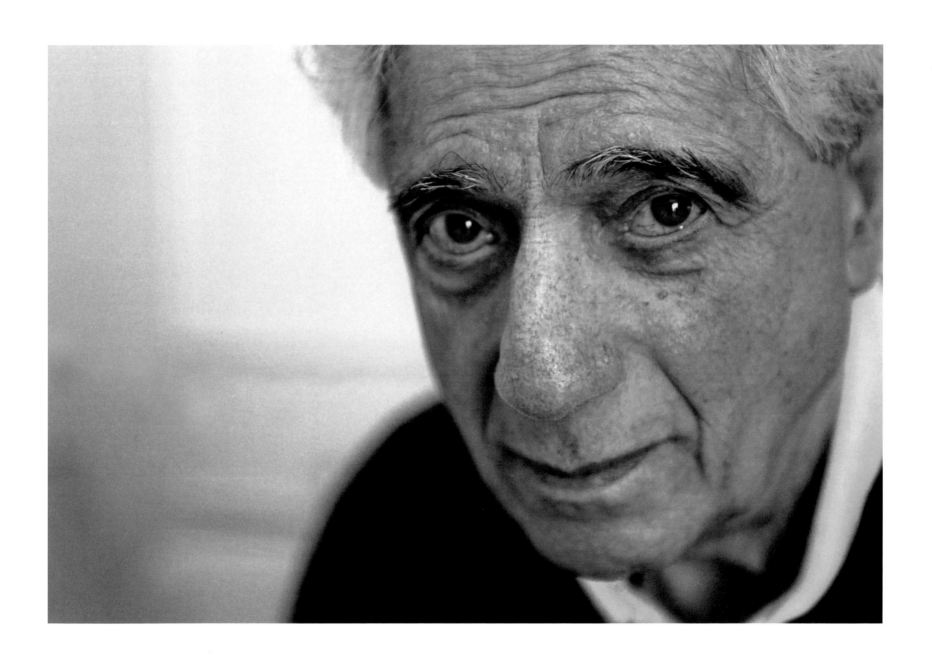

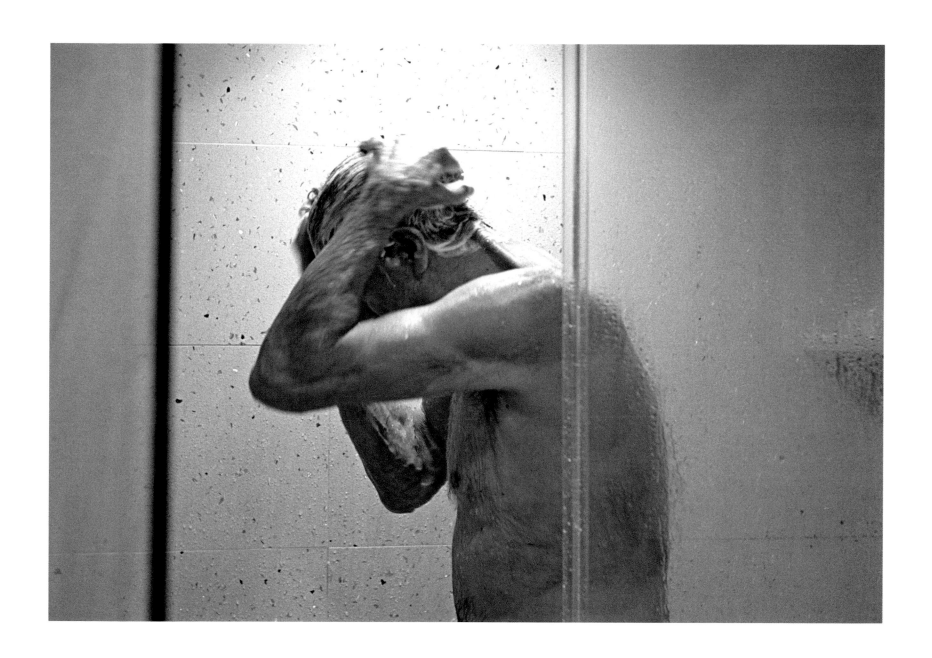

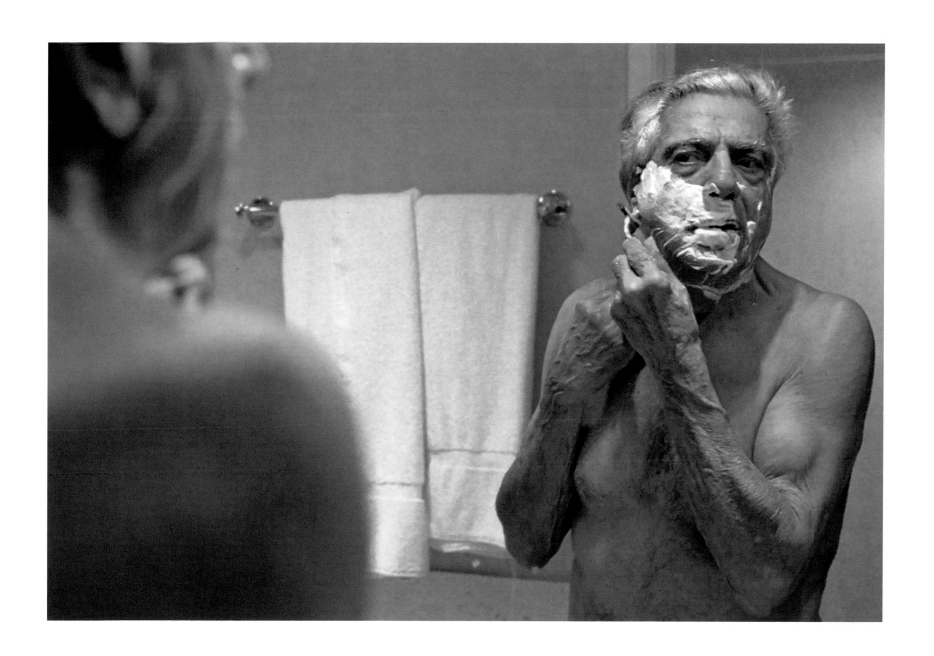

Sometimes, "good enough" is good enough.

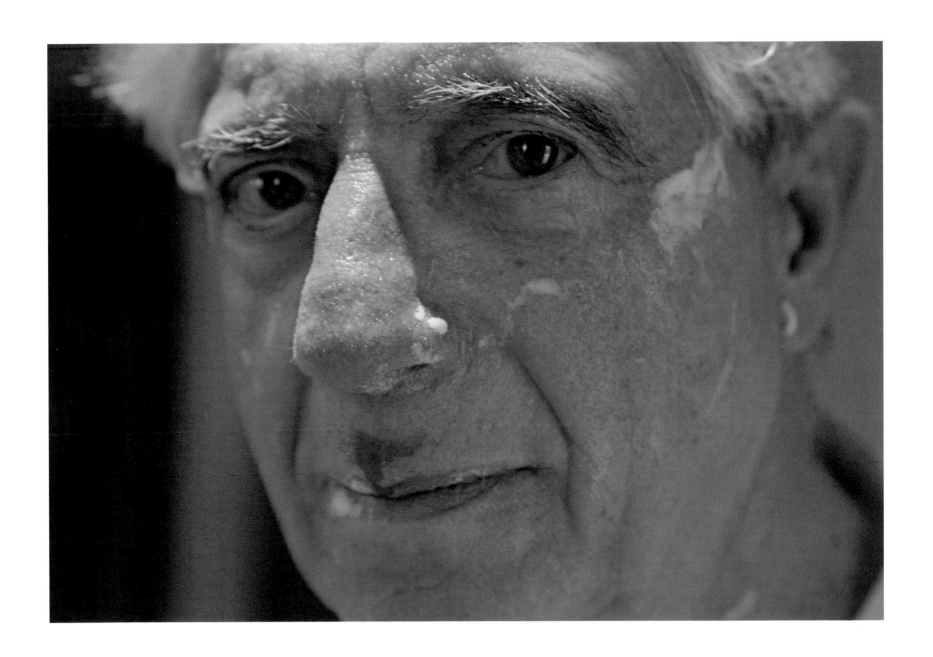

My first husband, Jerry, and Ed were close friends.
Before Jerry died (age 53, cancer) he told me
that he thought Ed was having memory problems.
I hadn't seen it, maybe because I knew
Ed had a selective memory.
He was brilliant but he had trouble remembering
anything he didn't consider important.
So how could I tell if he had memory problems?

And how did Jerry know?

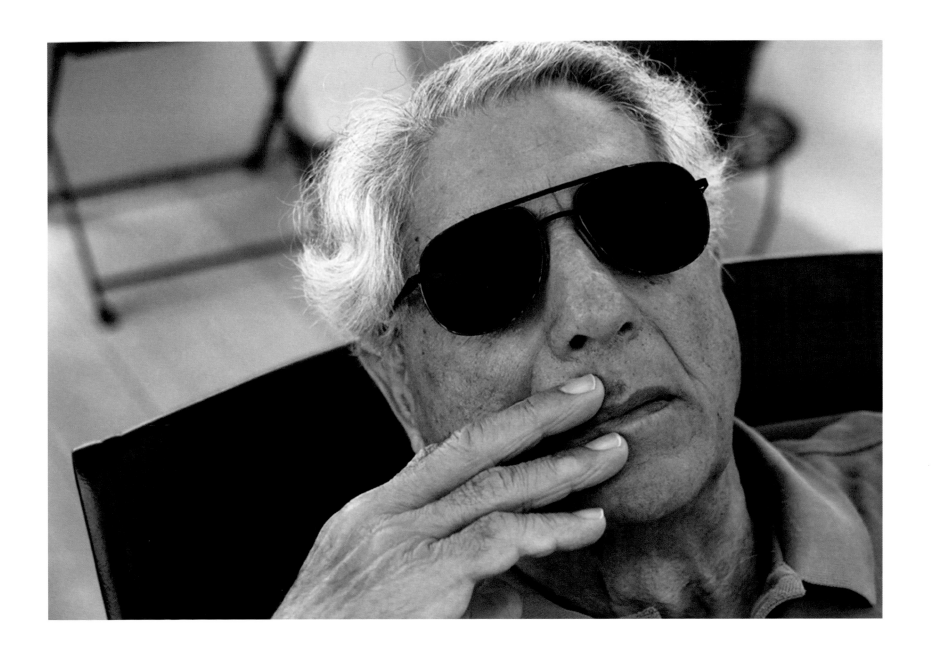

Ed flew a single-seat carrier-based fighter, the Corsair, in World War II.
He was 18 and the youngest kid in the squadron.
He loved flying and hates war.

When we visited the Air and Space Museum in Palm Springs,
I found this cap and bought it for him.
When he wears it, men in their thirties and forties come up to him and
thank him for serving our country.

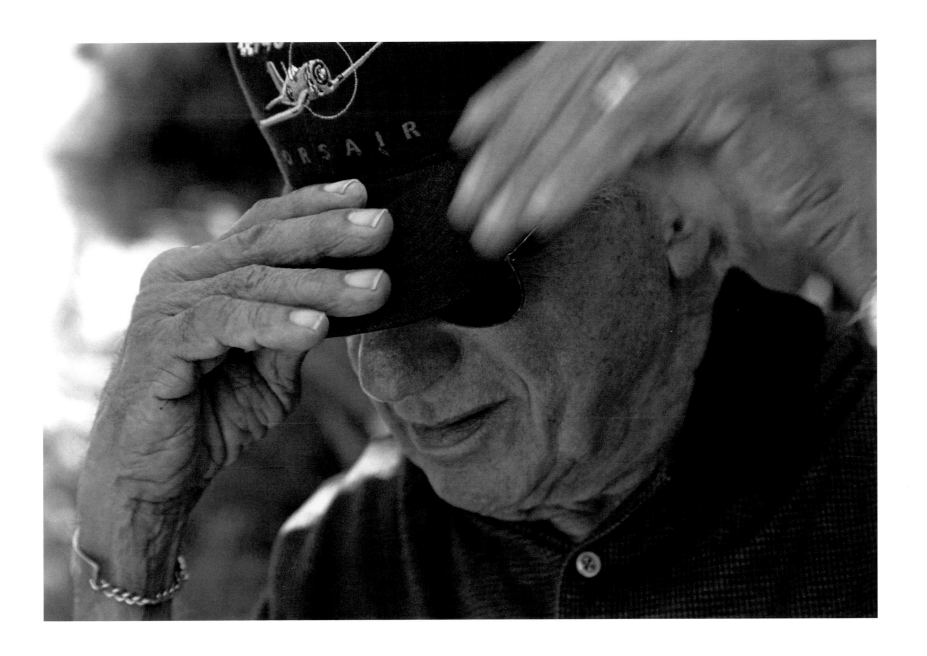

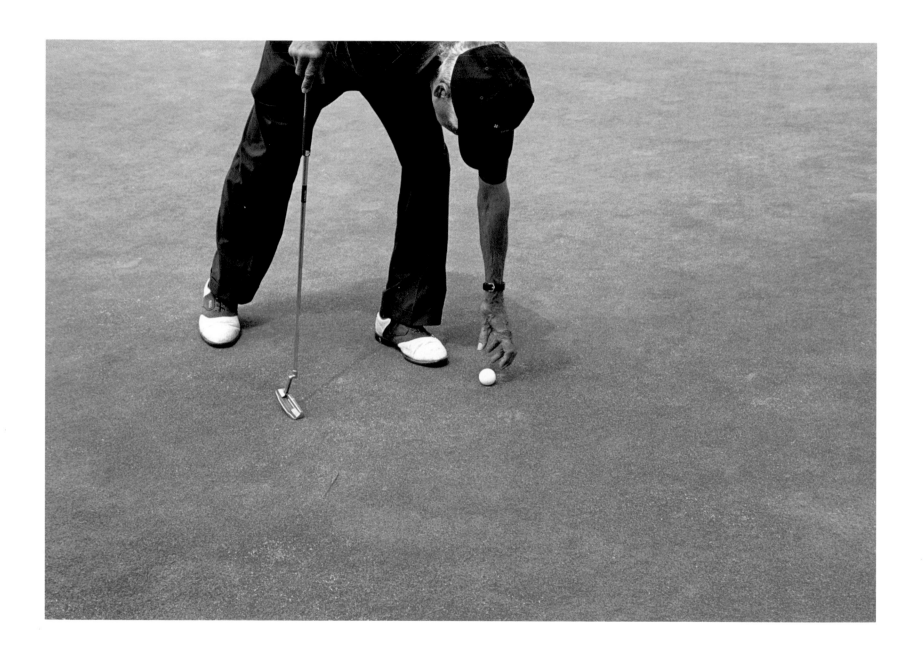

Ed is a natural athlete.
He went to Holy Cross on a baseball scholarship
and played on a Yankees' farm team
for a summer.
His real love, though, is golf and,
despite his extreme visual-spatial difficulties,
he won't abandon it.
When he's concentrating on golf,
he's not thinking about Alzheimer's.

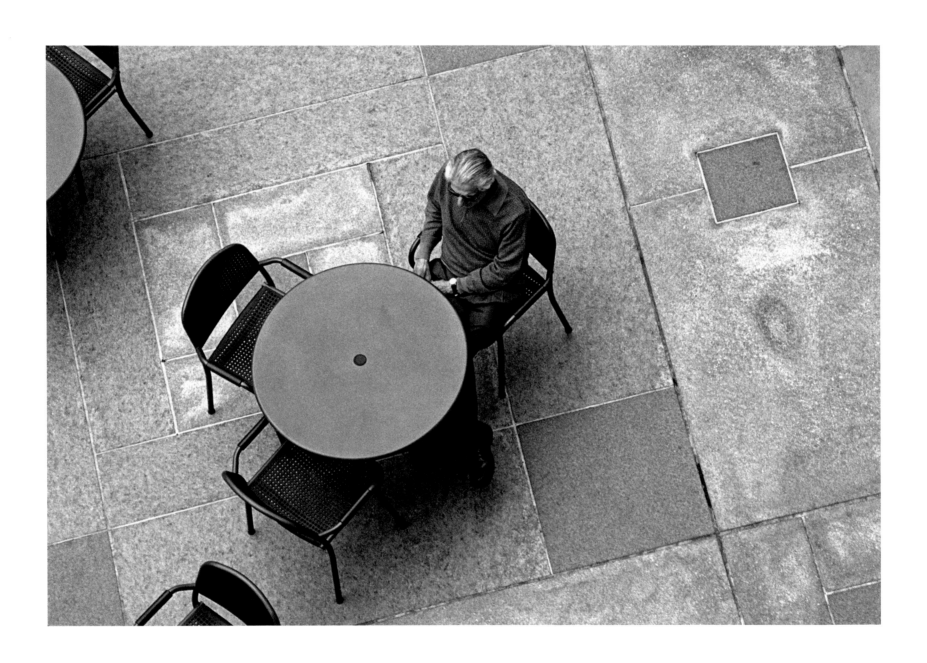

What Ed wants most is friends, buddies,
the kind of men who used to gather around him
when he was president of a university
and a hero on the golf course.
What he wants is to sit over a beer with these men
after a game of golf and talk about politics,
business, and sports.

He wants his old life back.

Everyone tells me to take care of myself.
Everyone tells me I need to take more time for myself.
Everyone tells me that if I don't take care of myself,
I won't be able to properly care for Ed.
I know everyone means well.

But I need help, not advice.

These are some of the things that help me cope:
friends, family, and a support group.
My personal favorite, though,
is mint chocolate chip ice cream.

I bought our cat, Honey,
thinking she would be good for Ed.
We're both madly in love with her,
but she and Ed have a special bond.

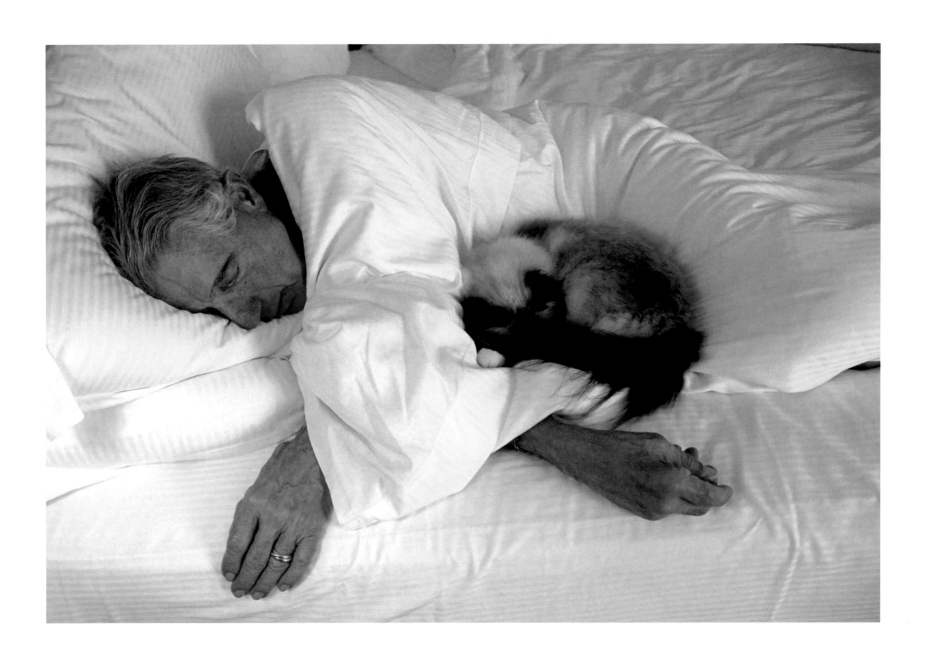

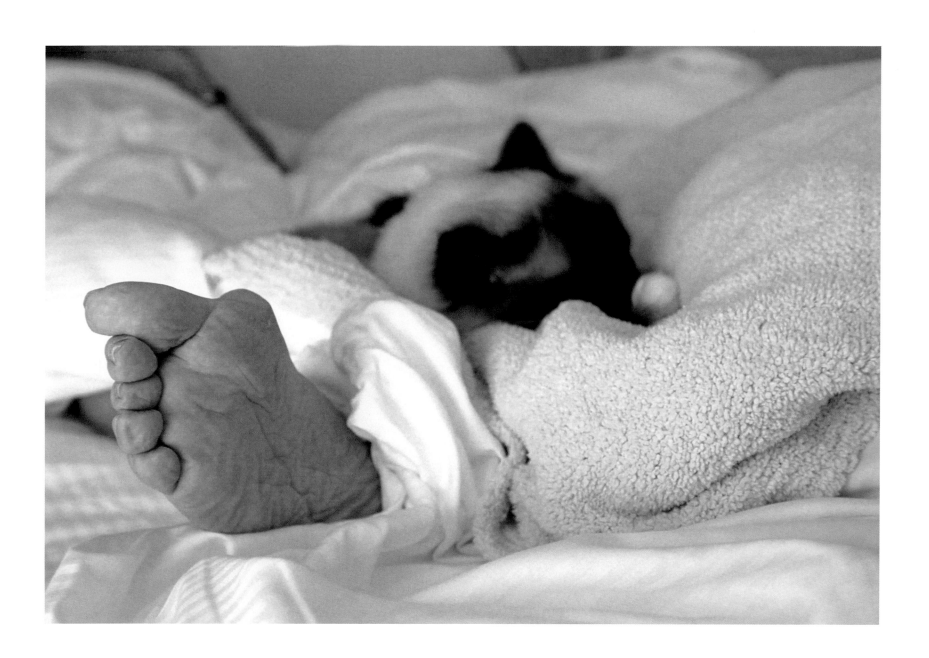

Alzheimer's doesn't announce itself
with an ache, a pain, a limp.
It rolls in like a fog.
It dissipates.
It leaves space for denial.

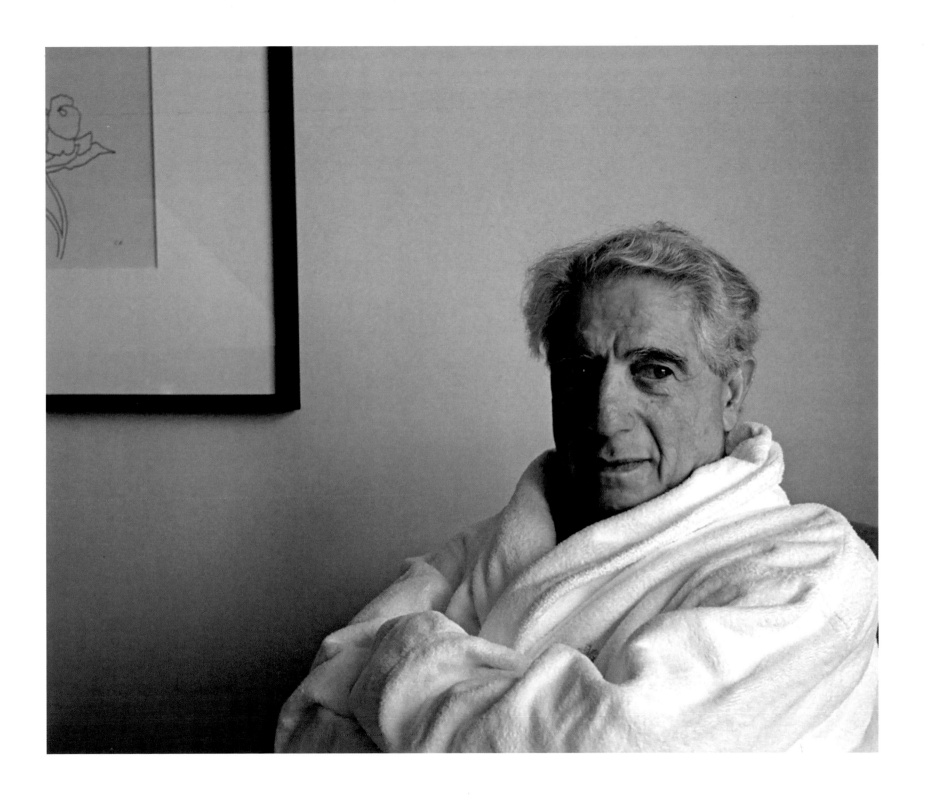

For several years, Ed didn't want people to know
he had Alzheimer's. He wanted to be treated with respect
and he didn't want people to think he was "crazy."

There are many incorrect assumptions about the disease—
some held by the people who have it.

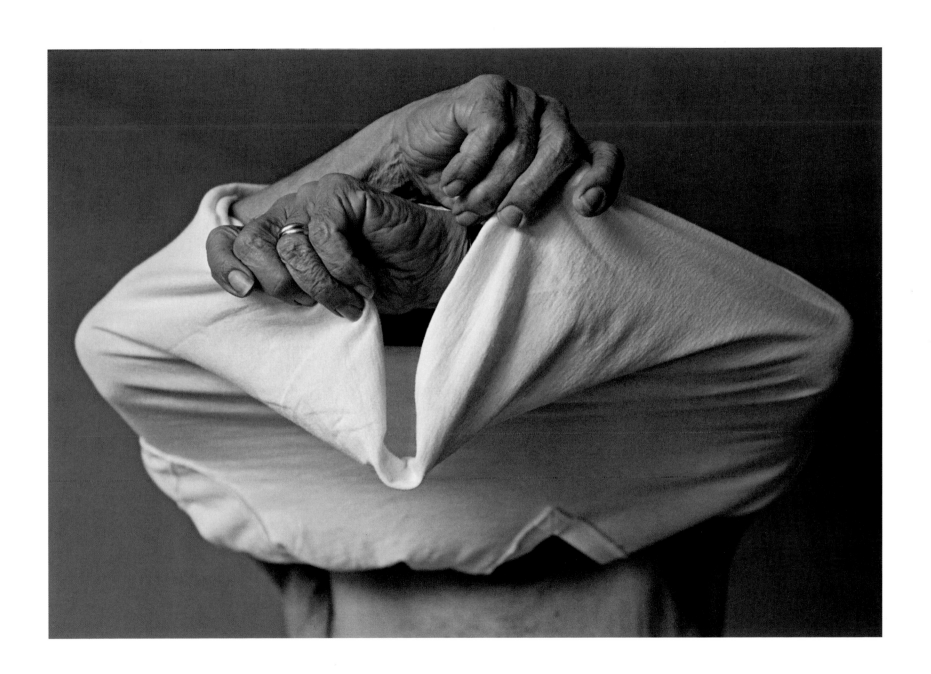

Our stories ground us.
We select them, we edit them,
and we tell them to others
in order to explain ourselves.
Ed is losing his story.

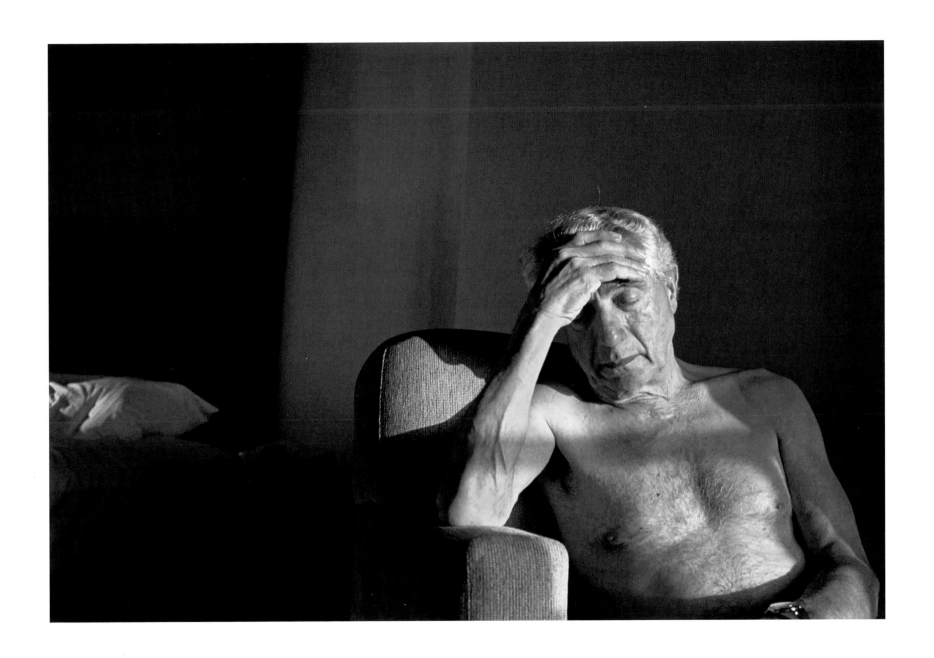

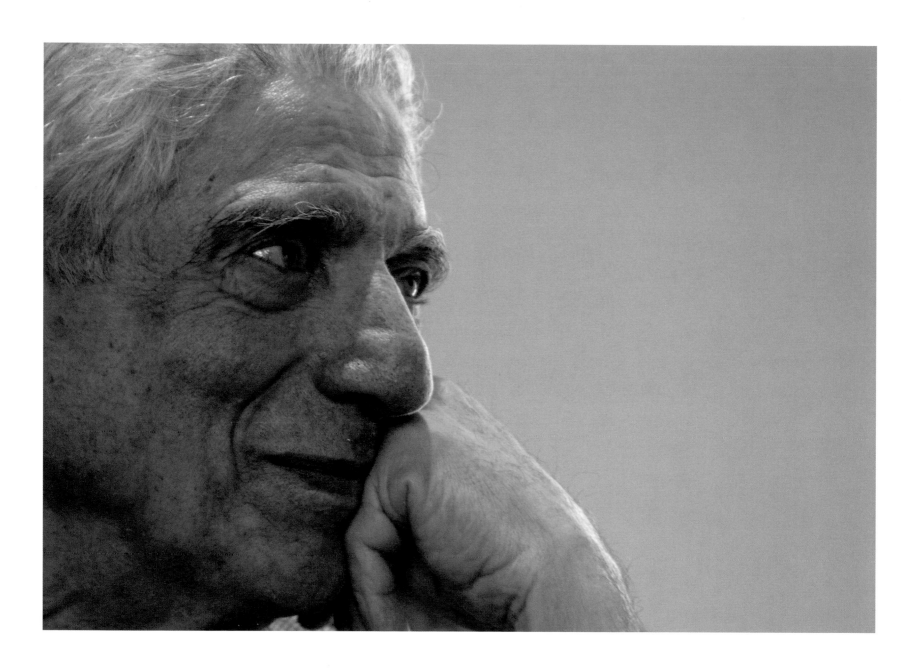

Why do family caregivers do what we do?

Is it an instinct to protect?
A willingness to sacrifice for someone we love?
Is it responsibility?
Guilt?
Lack of options?

Or is it, perhaps, an understanding
that we can do no less
and the hope
that someone else would do no less for us?

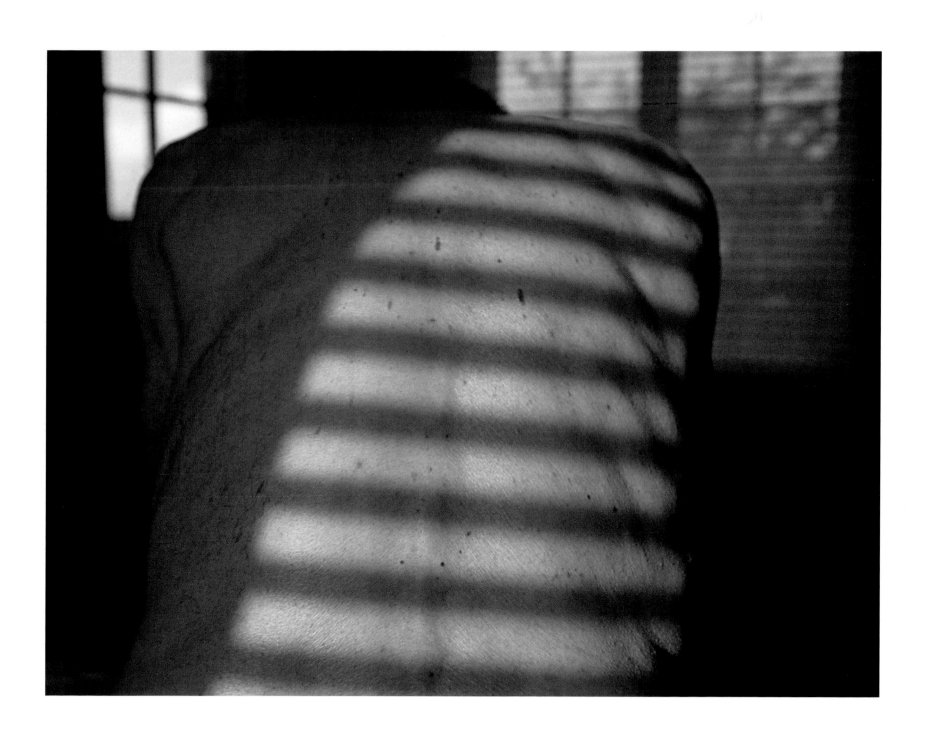

Alzheimer's is a disease that affects entire families.
Some join together to support the patient and the care partner.
Some uncouple and fall apart.

All are tested.

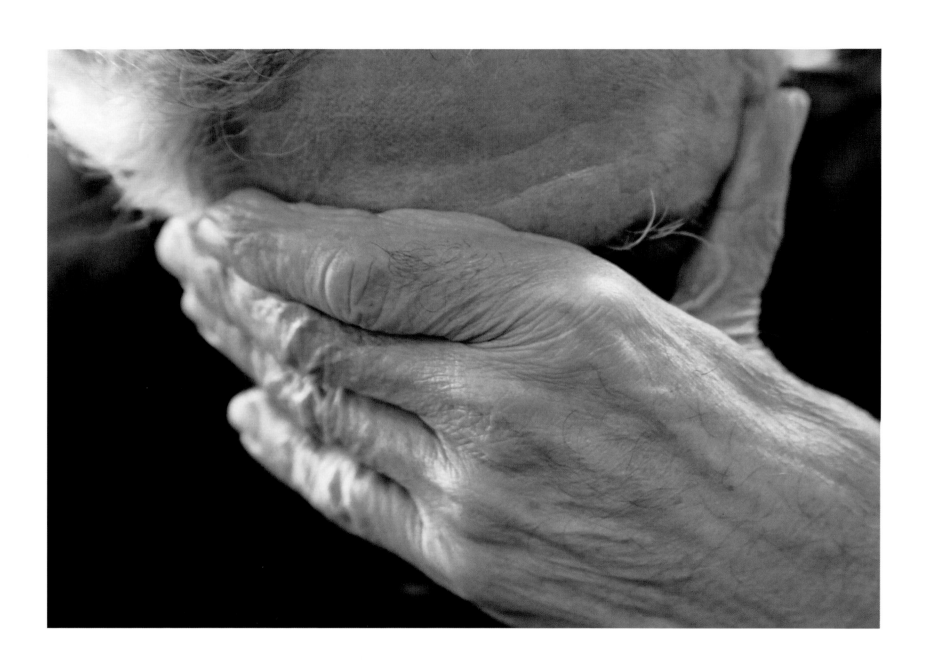

Alzheimer's is not without the occasional gift:
most patients keep their humor and wit
even as the disease progresses.
Laughter allows Ed to feel normal
and it deflects attention away from the fact
that he might not be able to answer the question,
recall the name, or find his way to the front door.

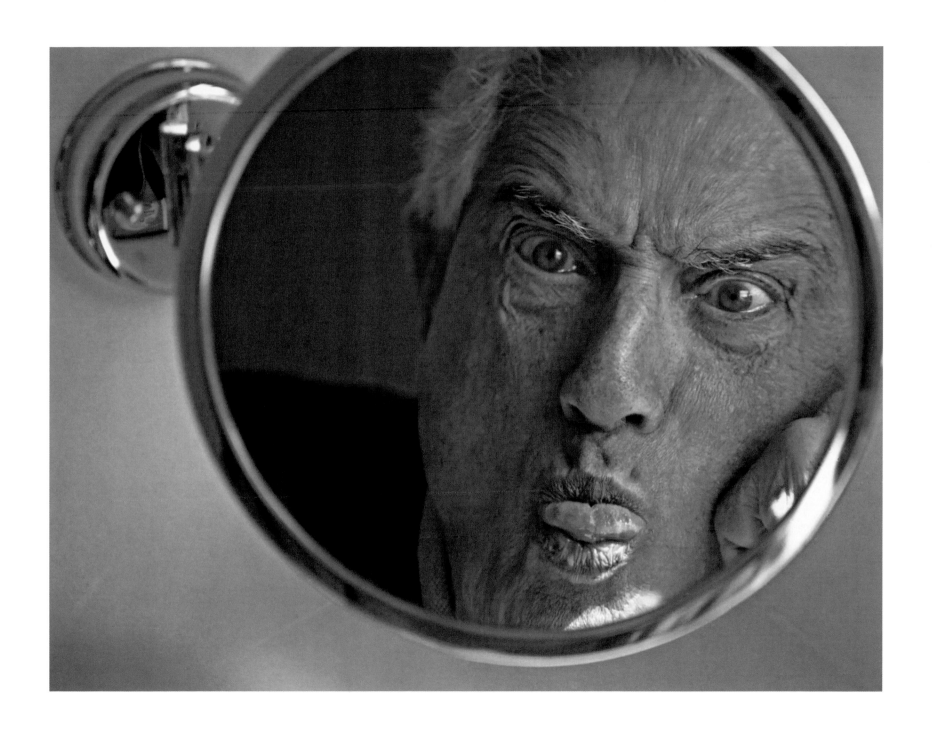

Sometimes I feel as though
I've left the theater of my own life
and turned up on the set of a Marx Brothers movie.
And thank goodness for the laughs.

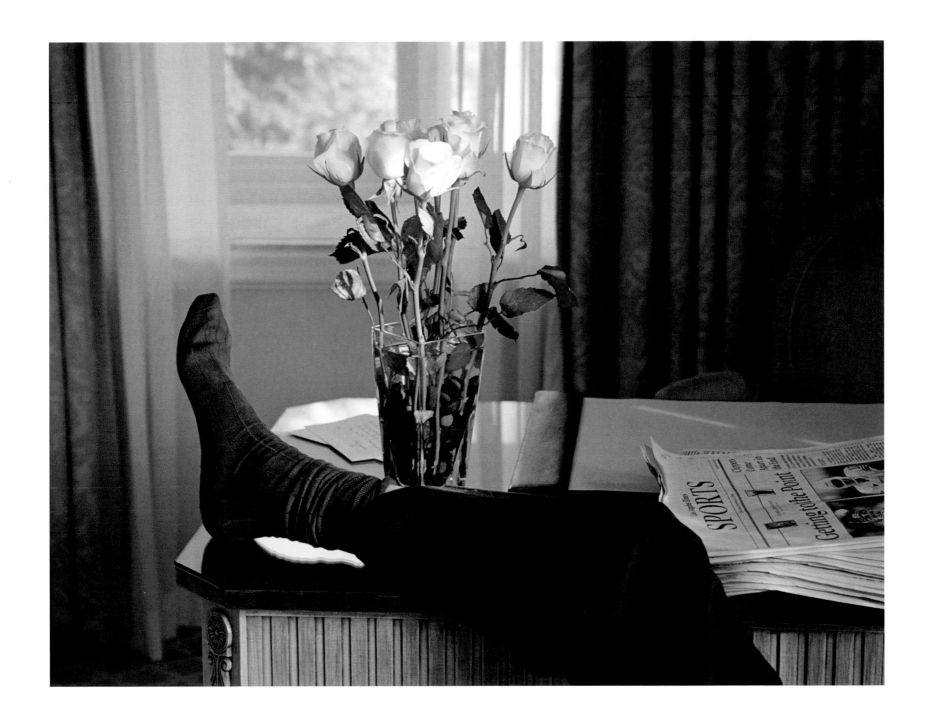

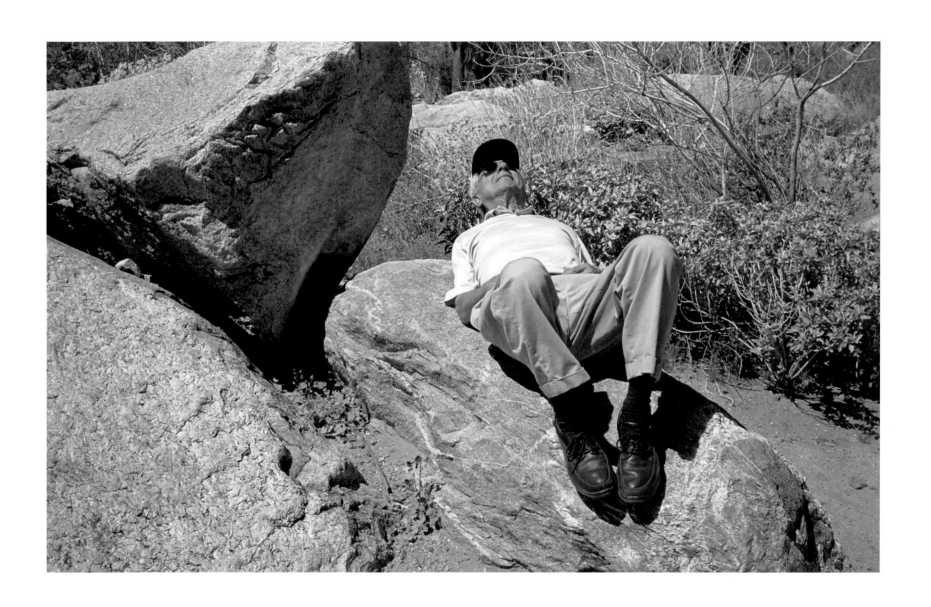

Ed and I enjoy the moments.
But I'm in charge of storing and sharing the memories.

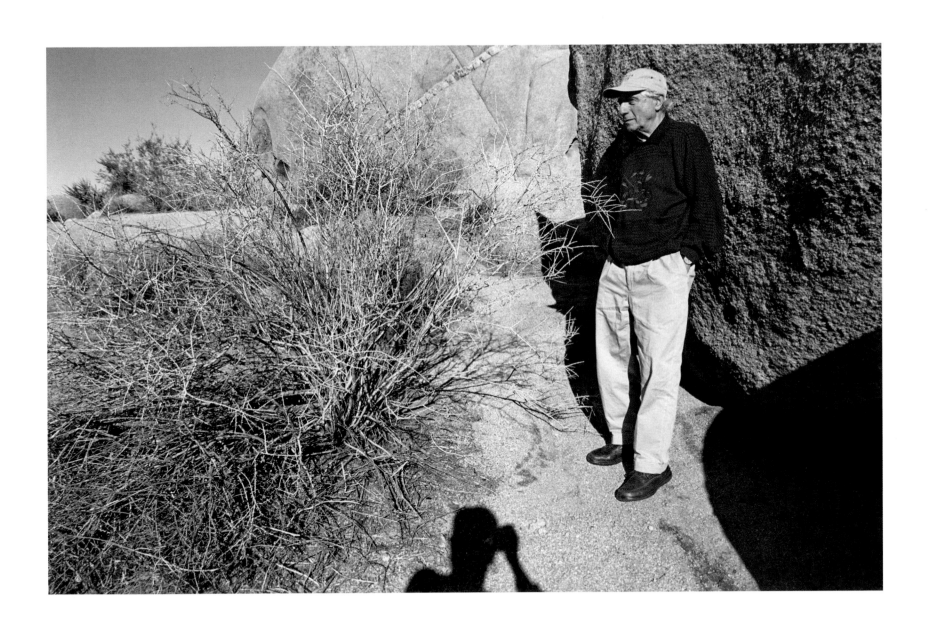

Ed has beautiful hands;
I could photograph them all day long.
His hands are large and soft and warm and must have been
a comfort to his patients when he was a surgeon.
I know they're a comfort to me, now.

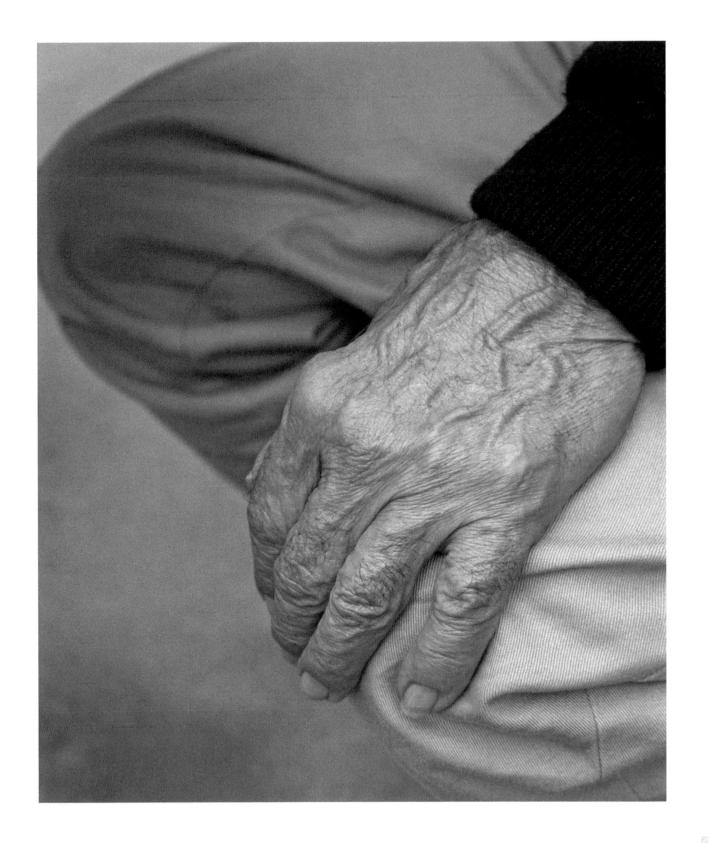

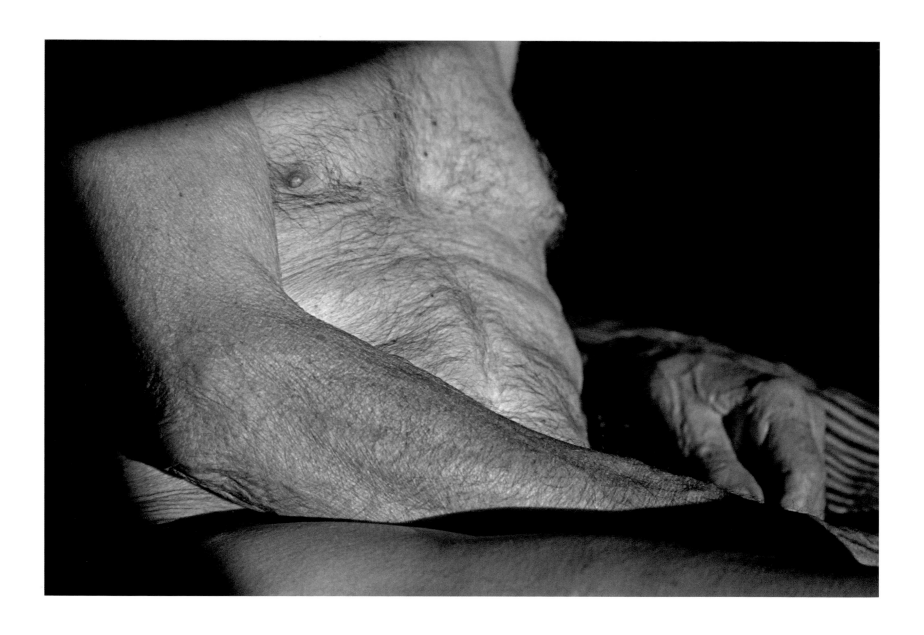

I told Ed that some of the photographs
I took of him saw straight through to his soul
and asked if he minded being that exposed.
He said "No. You can show my soul;
just don't show my penis."

So that's our agreement.

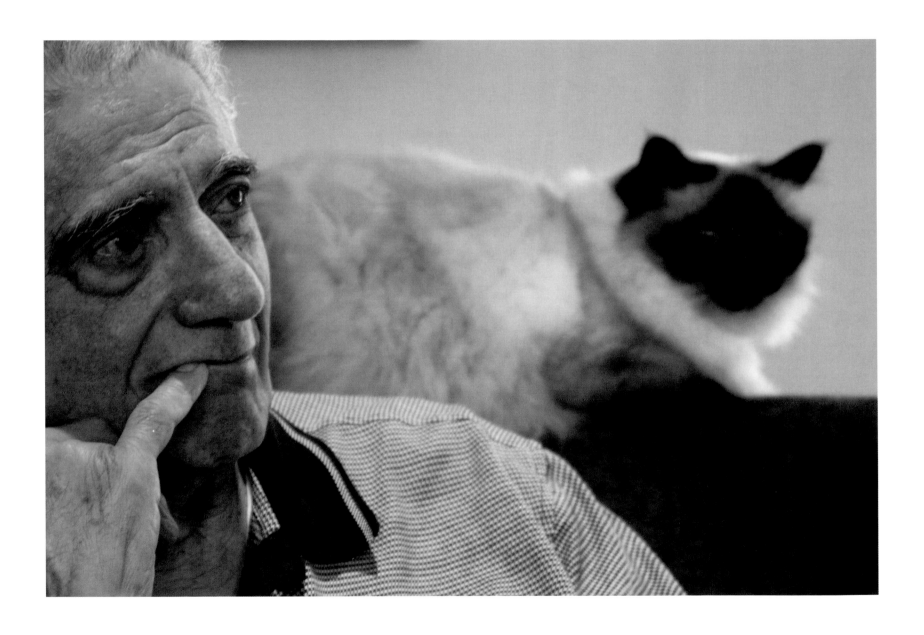

We strive, as do millions of others,
to figure out ways to live in the presence of a disease
that mercilessly erases my husband's life
bit by bit, memory by memory.
Some days we manage, some days we don't.

People with Alzheimer's often feel worthless.

Worth less.

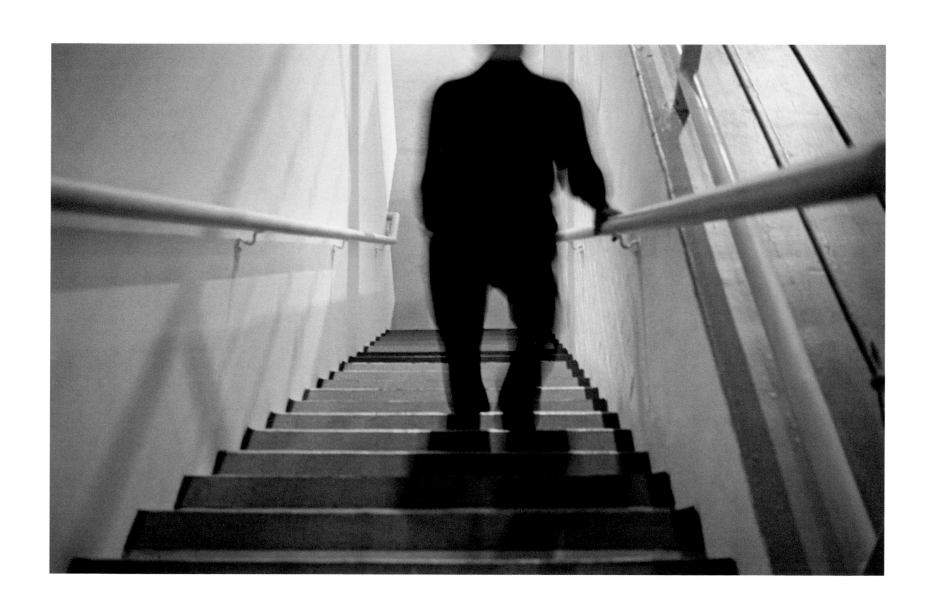

Alzheimer's taunts and jeers. Yanks our chains.
Unveils the person we married and then replaces him
with someone who doesn't know our name.

How are we supposed to deal with that?

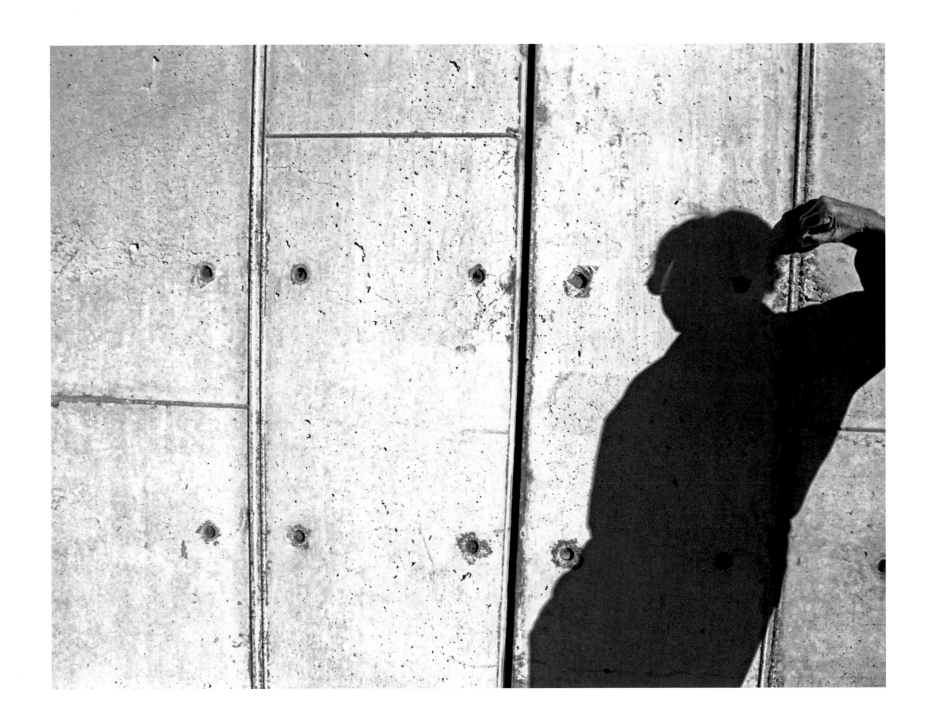

This disease is a shape-shifter.
Sometimes it almost looks human.
Then it twists, warps, and snakes.
And it grabs hold of Ed and me and it squeezes.
And squeezes.
And squeezes.

Once Ed and I started living with Alzheimer's,
we began a trip down a never-ending staircase.
Here and there we've found a platform
and rested for a while.
Then there was another step down.
And another.

Right now Ed and I are tumbling feet-over-head.
No platforms in sight.
A nightmare.

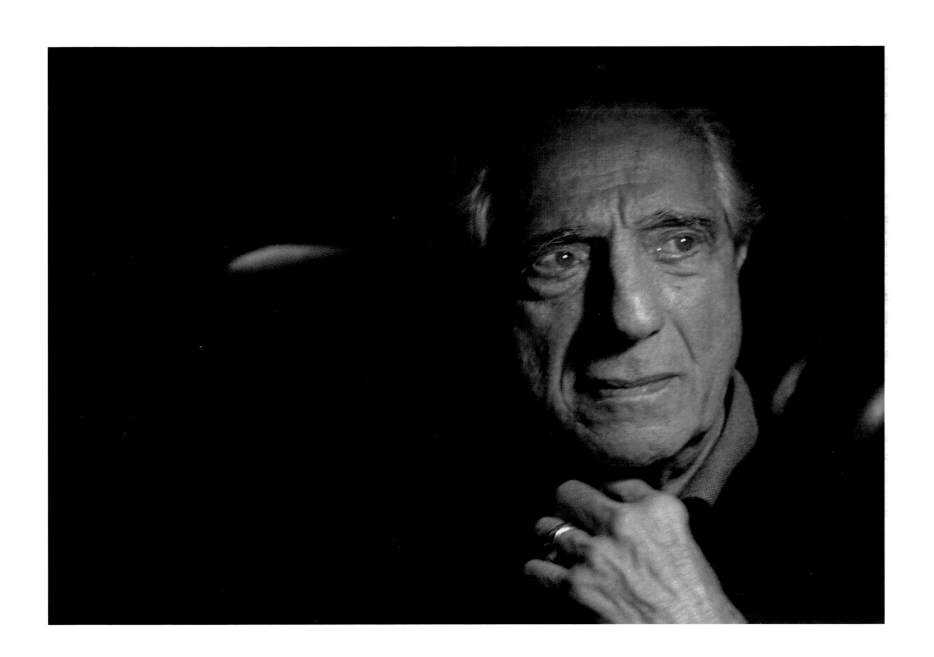

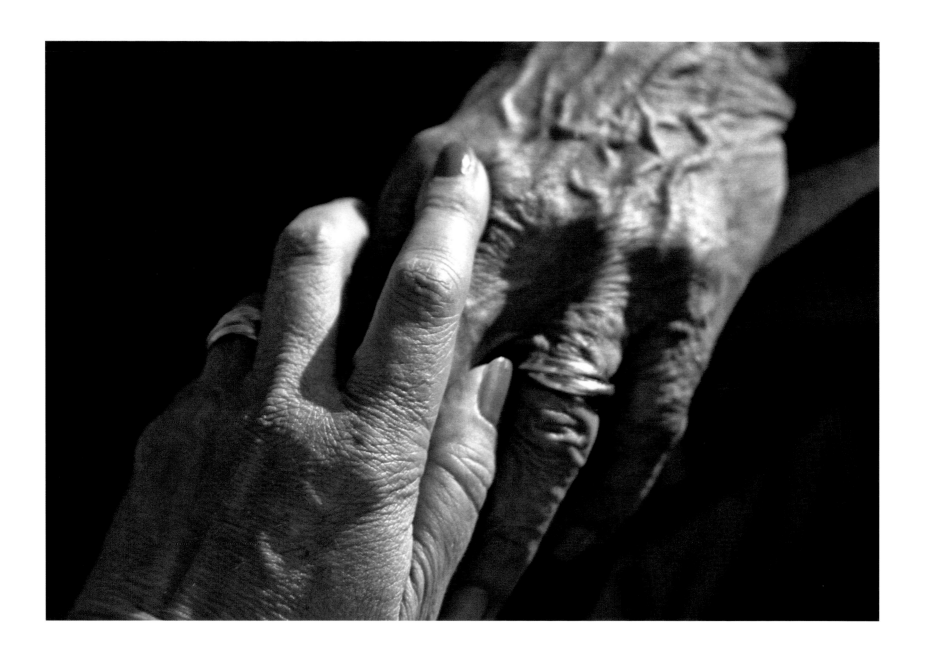

In the midst of a devastating disease,
there are still lovely moments, laughs,
hands held and bodies touched,
and the precious and fragile gift of time together.

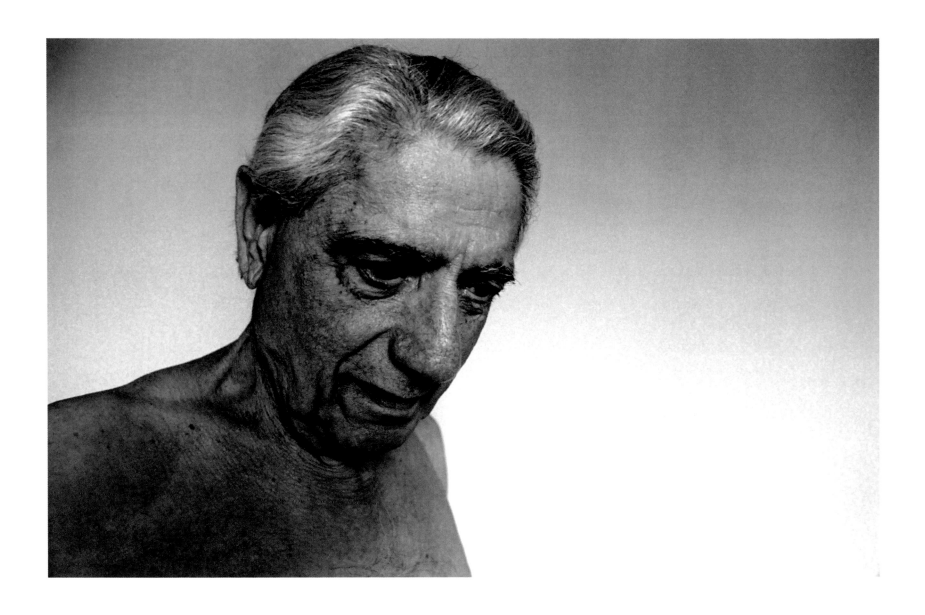

After the first eight years of trying to manage alone,
I hired a caregiver to help us during the days.
But I'm still Ed's nighttime caregiver—
a role I chose and treasure.

Someday I might run out of options
and I'll have to relinquish the post.
But, in the meantime, we hold hands in bed;
we have quiet, generally uncomplicated conversations;
and we tell each other "I still do…"

When we choose to help ease the life and death
of an Alzheimer's sufferer, we are taking on
a difficult, demanding, and heartbreaking role.

And, yes, it's also a privilege.

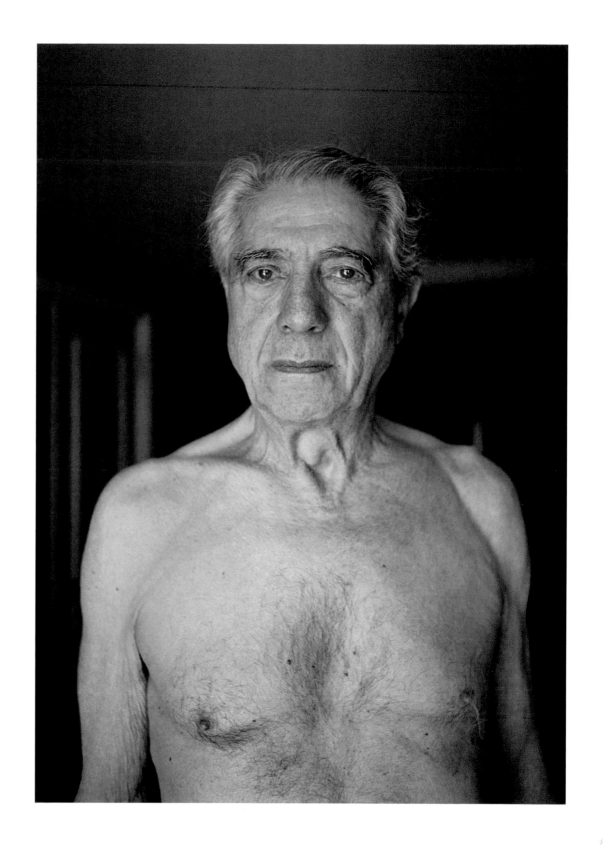

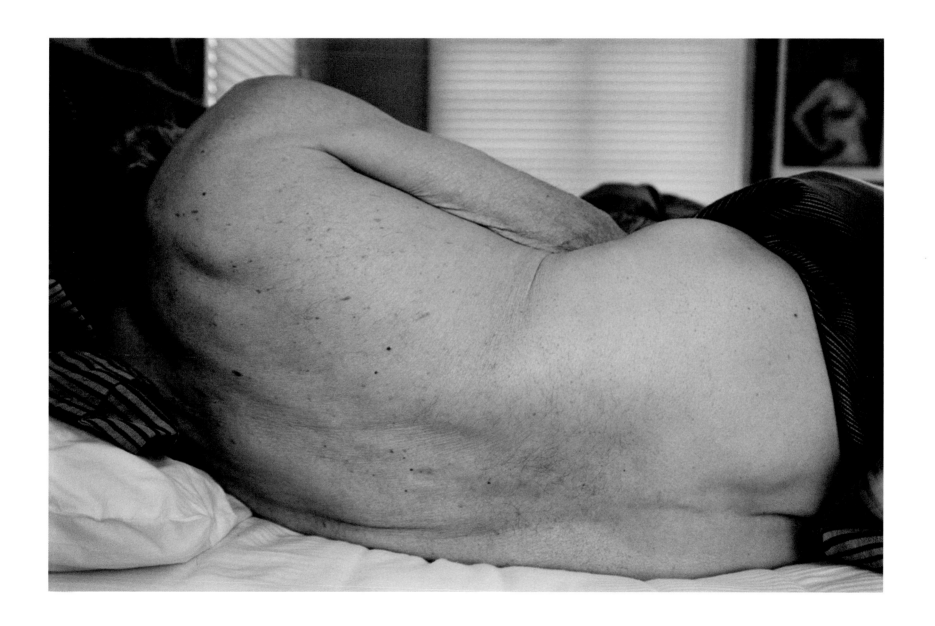

Ed is still aware of his decline;
he's able to articulate his concerns.
I know what's going on in his head.
He expresses his feelings when he's awake
and he talks in his sleep at night.
When he's in a room by himself
he speaks his thoughts out loud.
There are no secrets.

Knowledge can be painful.

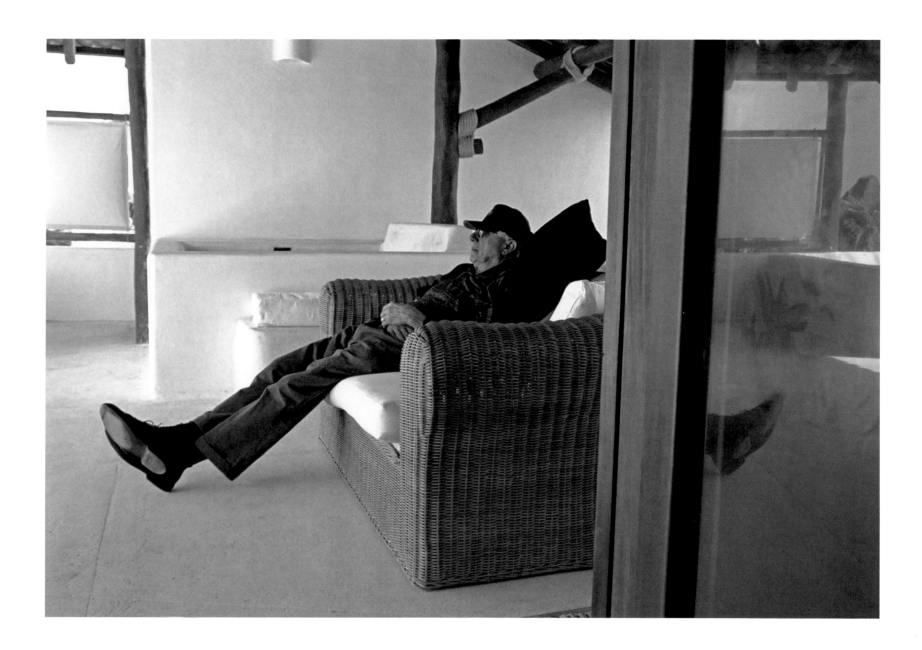

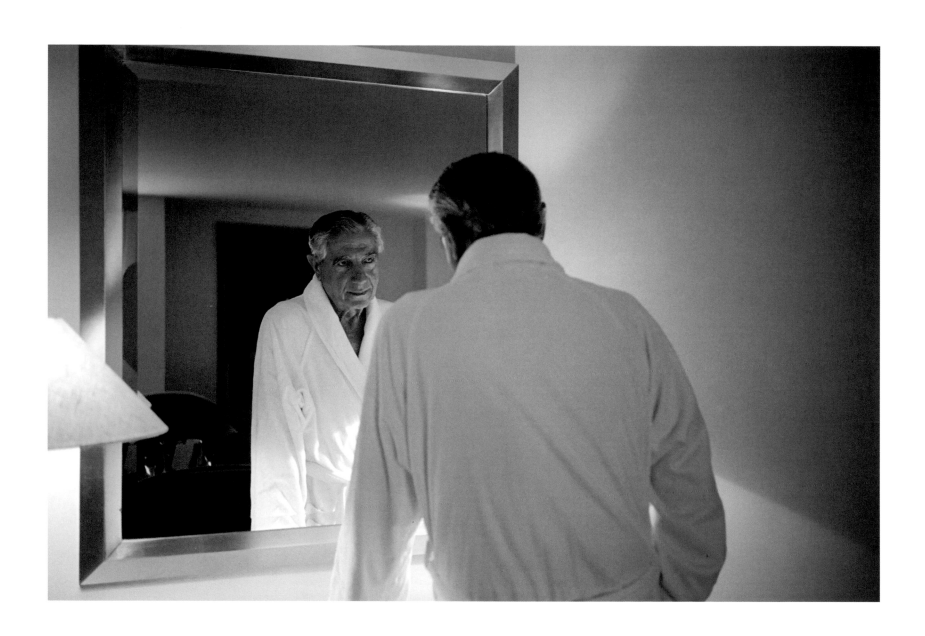

I sleep poorly. Like most Alzheimer's partners.

When Ed's awake at night, I'm awake.
And he's awake often.
So, when he gets up to go to the bathroom,
I'm there to make sure he heads in the right direction.
When he jumps out of bed at three a.m.
because he thinks he has a meeting to go to,
I settle him down.
When he gets up at five a.m.
because he thinks he's misplaced his wallet,
I'm awake to help him find it.

When I go out-of-town for a week, I sleep for the first three days.

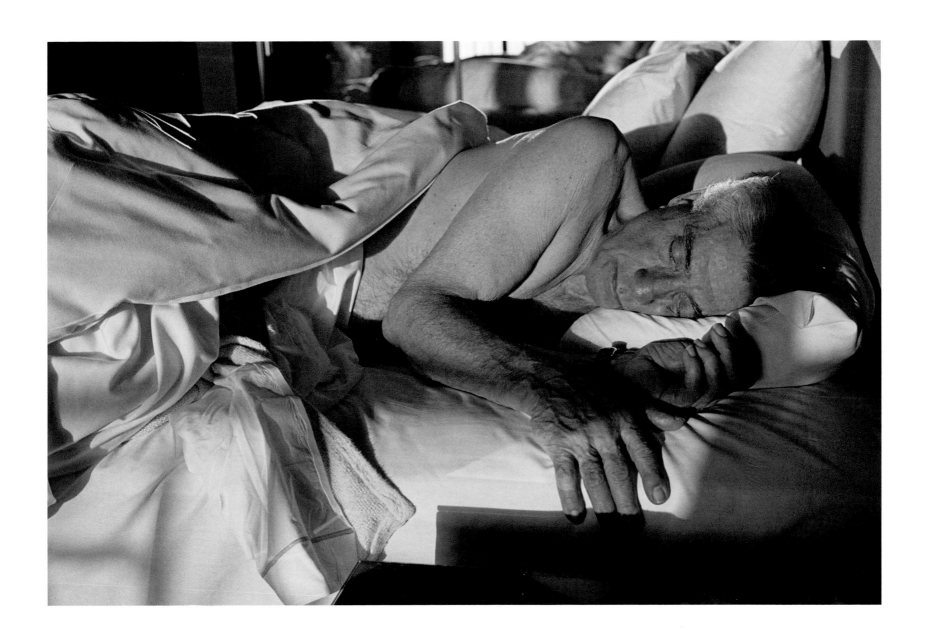

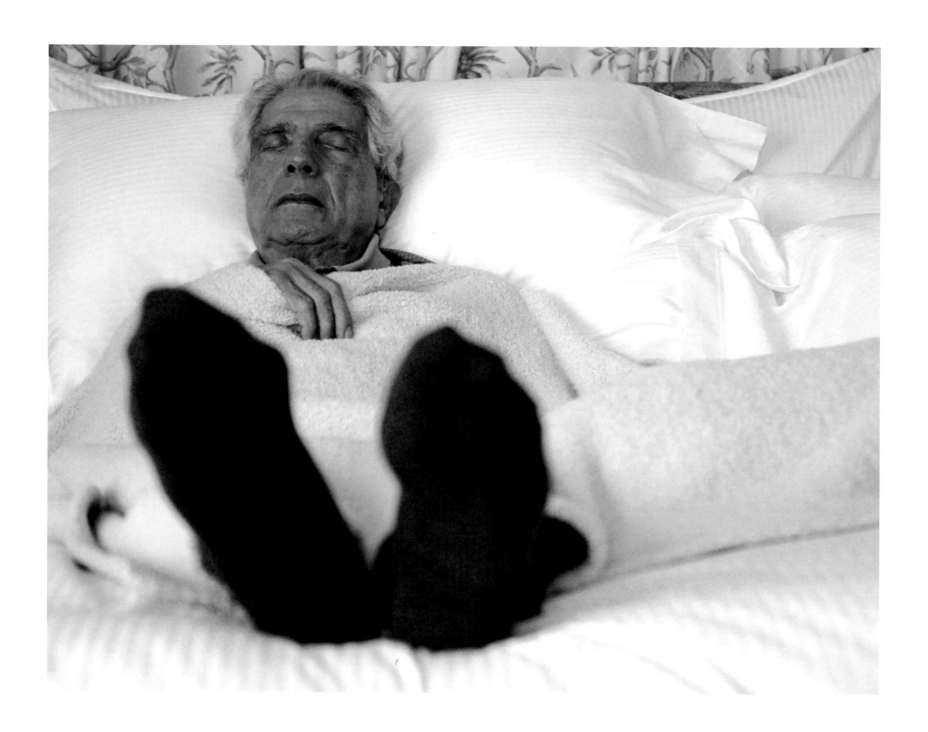

It's tiring to battle A.D. and Ed's naps are more frequent now.
Also, Alzheimer's is a disease that cultivates boredom,
fed by a loss of initiative and abilities.

We work hard to keep Ed engaged;
some days I think it takes a larger village than we have.

Who thought up the innocent-sounding euphemism "sundowning"
to describe that anxious and erratic early-evening behavior?

Let's be honest, here.
How about "howling at the moon"? How about "clawing at the walls"?
How about the "twilight zone"?

"Sundowning"? Please.

Ed's mind is receding into the past.
He still knows me, but on a bad day his brain seamlessly
blends the past and the present and the maybe-never-was.

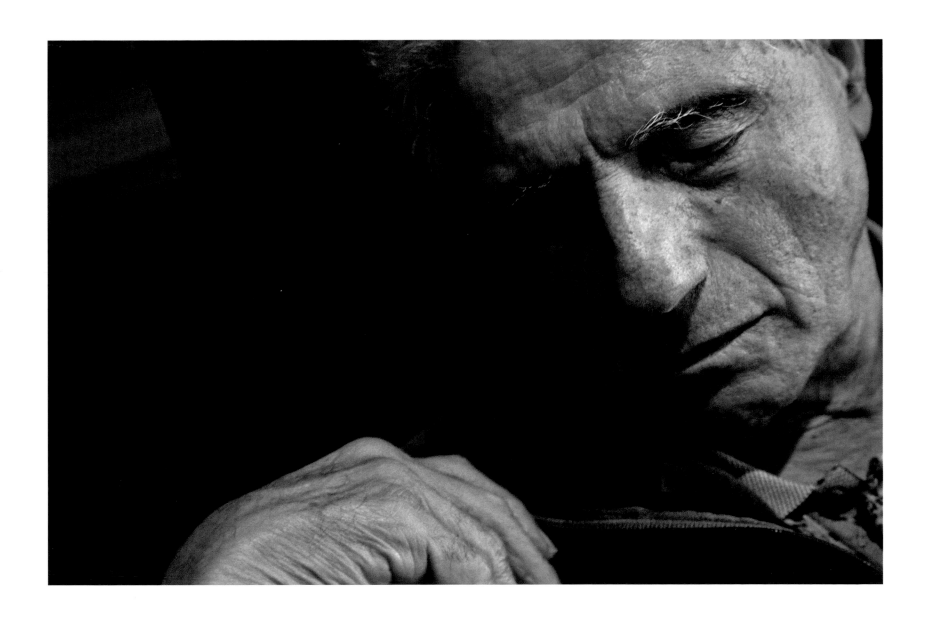

I'm enraged by Alzheimer's.
It's stealing my beautiful husband
and it's snatching years from my life.

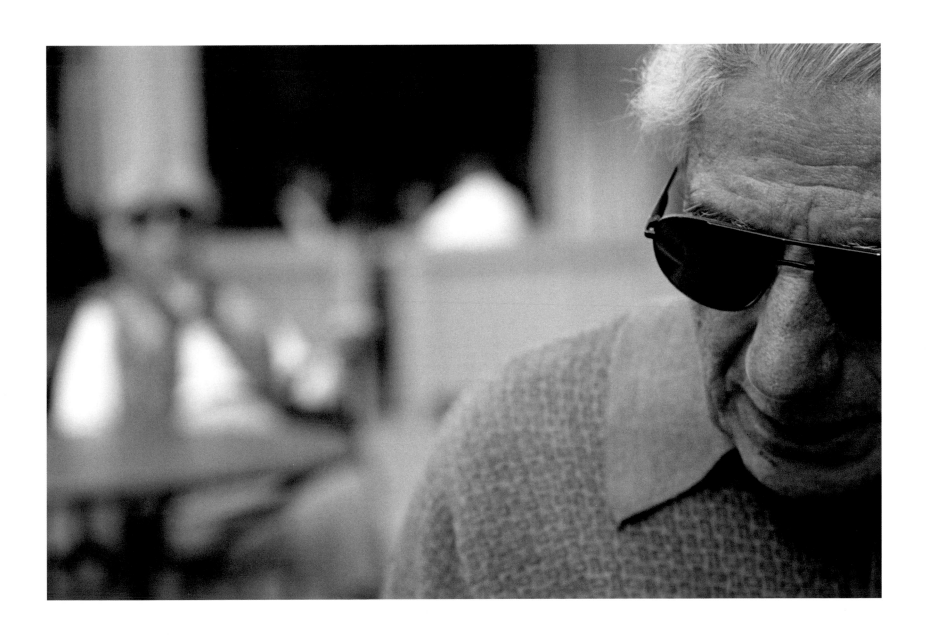

I don't think about the life Ed and I would be sharing if he were well.

What's the point?

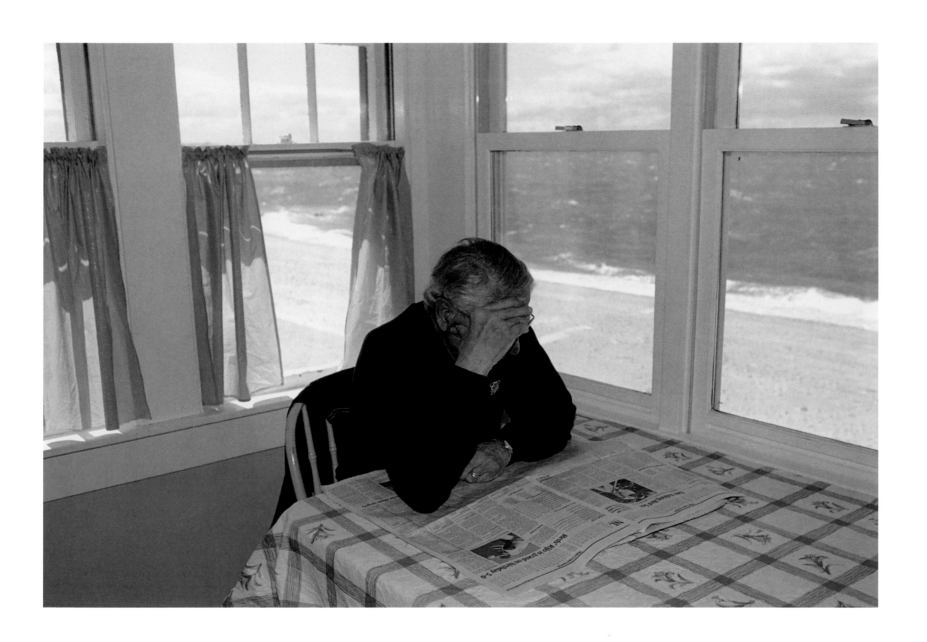

Ed's social skills remain undiminished.
He's courteous, charming, and considerate.
Strangers, even friends, can be fooled into thinking
everything's hunky-dory. For ten minutes.
Fifteen minutes, tops.

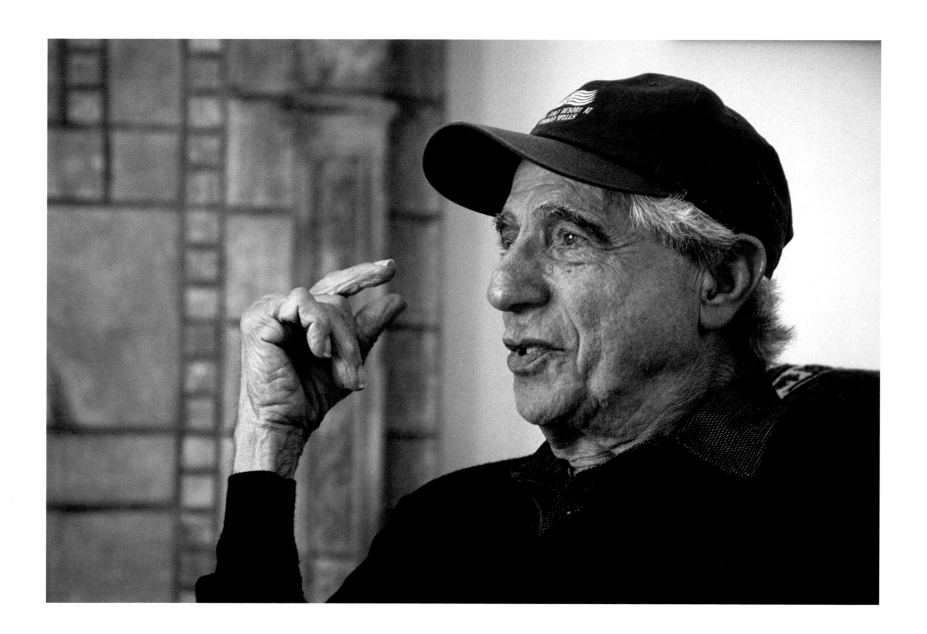

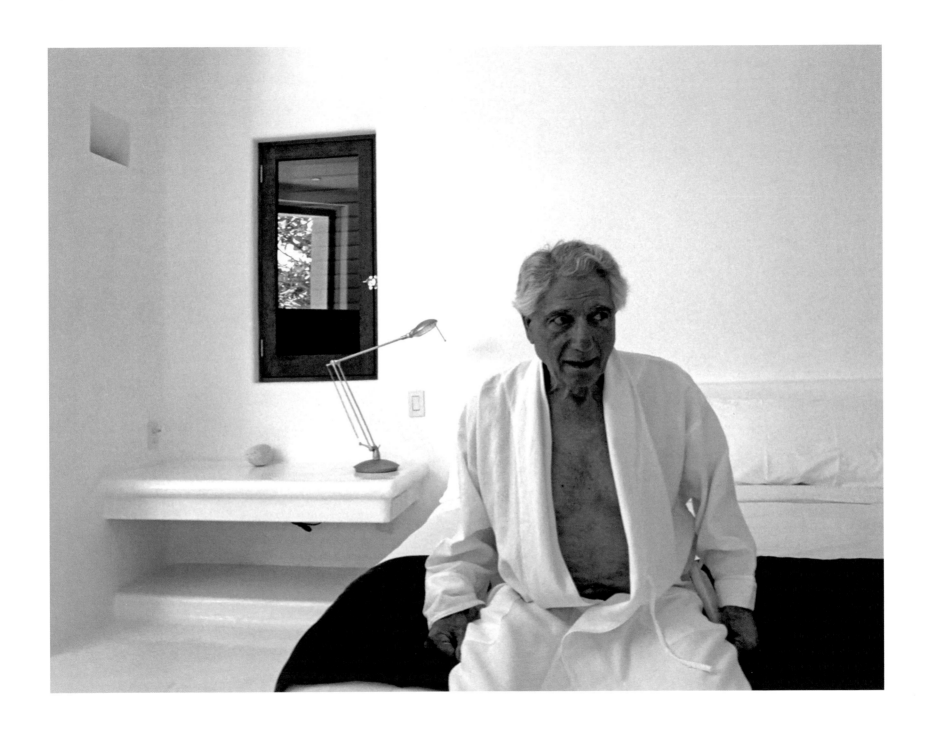

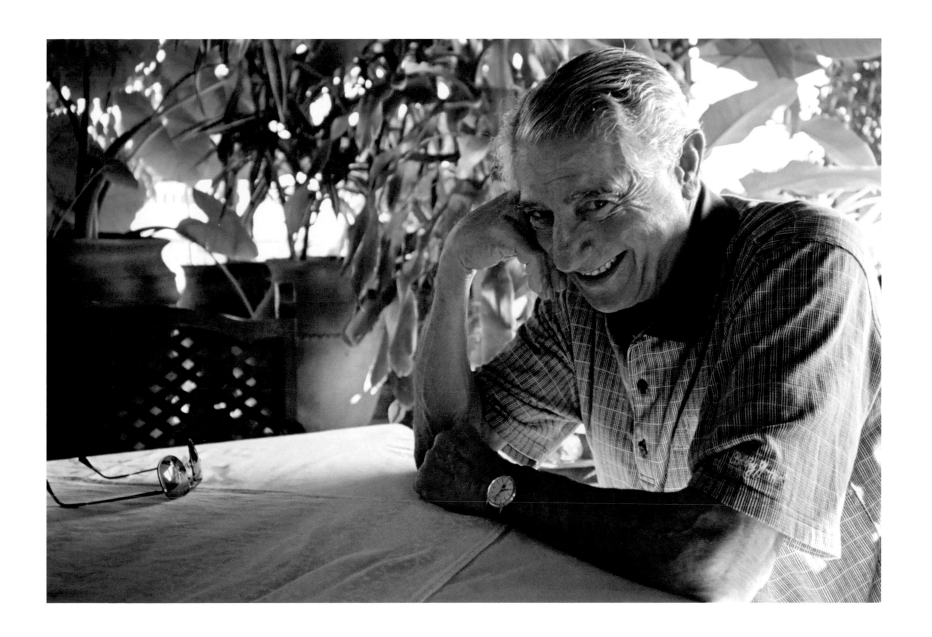

I love that Ed is delighted anew by familiar things.
When we drive through our neighborhood he says,
"This is territory I've never seen before."

I think there may be a lesson in that.

Ed's brain is a jumble of tangles and plaques.
It's an alternate universe with its own authenticity.
It's roller coasters and fun-house mirrors.
And rabbit holes.
I've stepped through the looking glass and into a world
where logic and reality are reconfigured.
Occasionally, it can be fun.
Often it breaks my heart.
Sometimes, it's just plain interesting—
a peek into the workings of the brain.

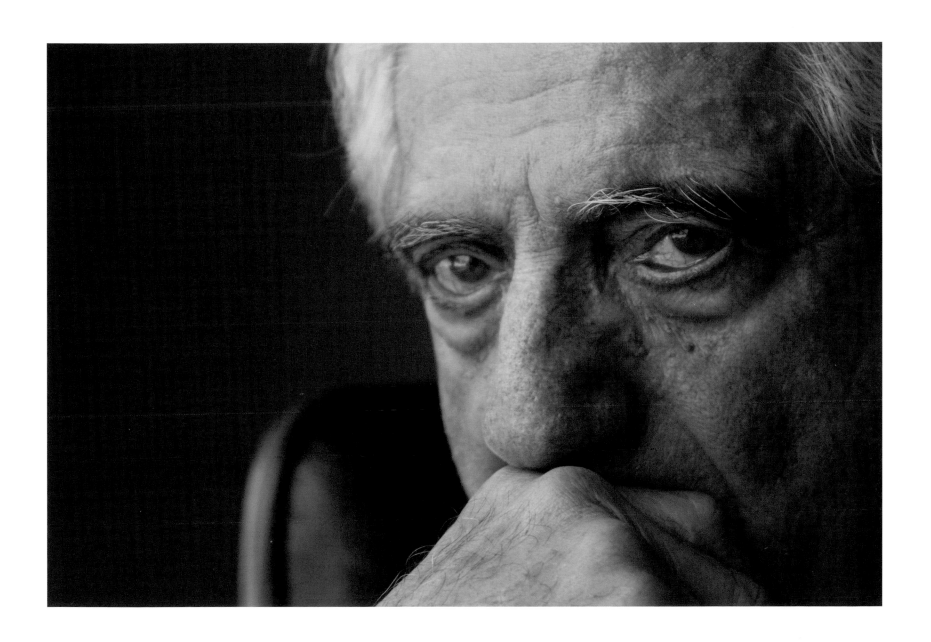

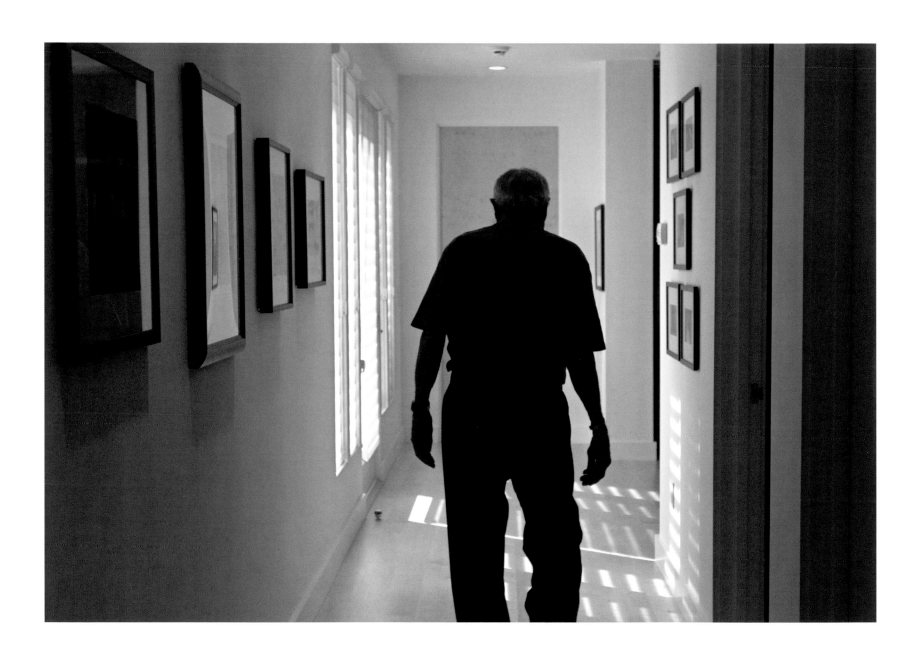

Ed is working very hard to fight his disease.
He attempts to ground himself.
He tries to figure out where he is and goes
from room to room in our home,
looking for the familiar.
He strives to organize his thoughts and memories.
It's a visible struggle and it's a valiant fight.
But he's losing, and his pain and anxiety are palpable.

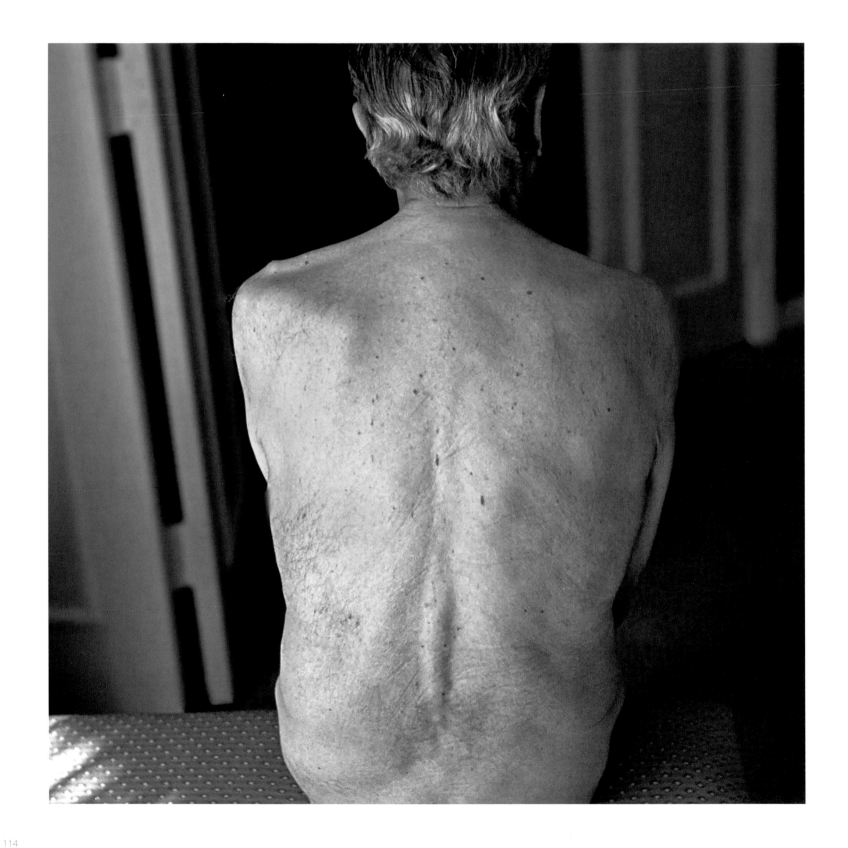

No matter where Ed lives in this world,
he will never again feel at home.
The floors have collapsed, the ceilings have opened,
the walls buckled.
Our house can no longer be counted upon
to give him stable shelter and protection.

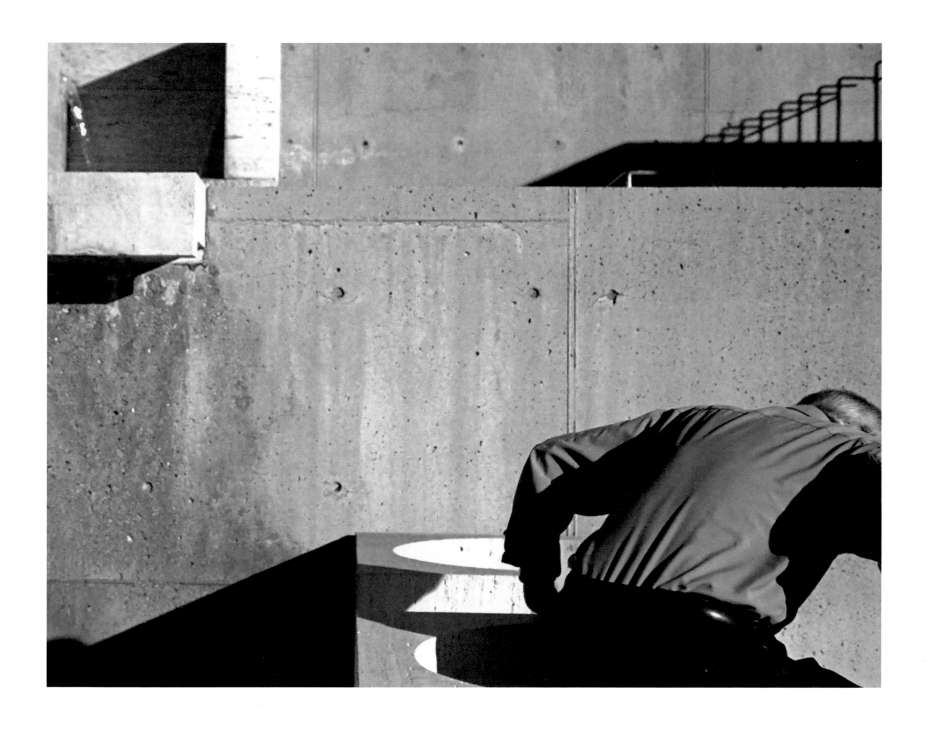

Recently, Ed said to me, "I'm so sorry I've done this to you.
I didn't realize how sick I was and I don't understand
how you can be so patient." Then he said
"I don't know why you didn't take me by the shoulders,
sit me down and say, 'You've got a problem and here's the story.'"

I didn't tell Ed how sick he was because he didn't want to know.
And I'll continue to follow his lead.
I'll try not to tell him more than he wants to know.
Or less.

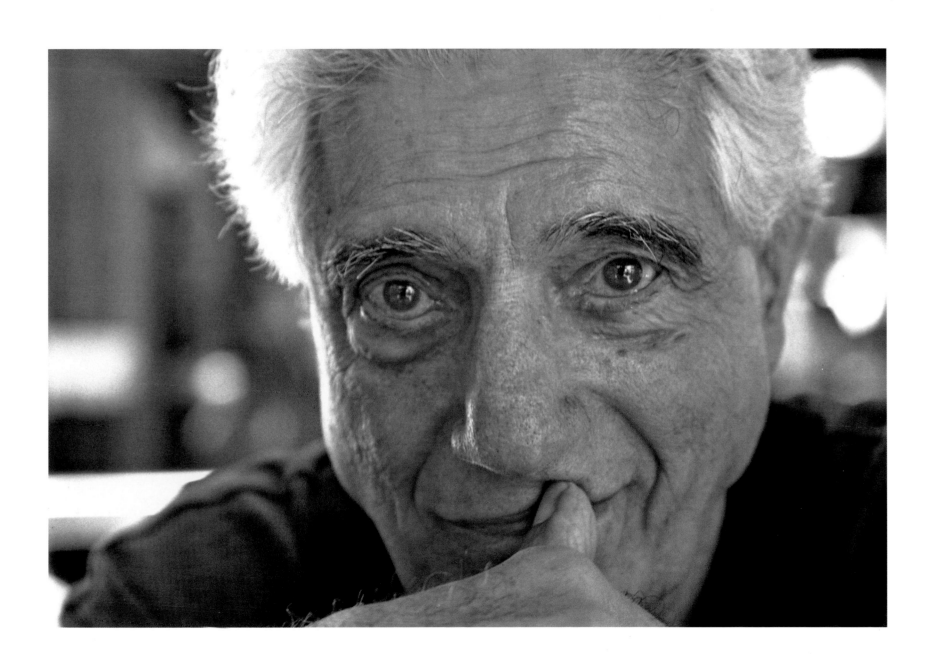

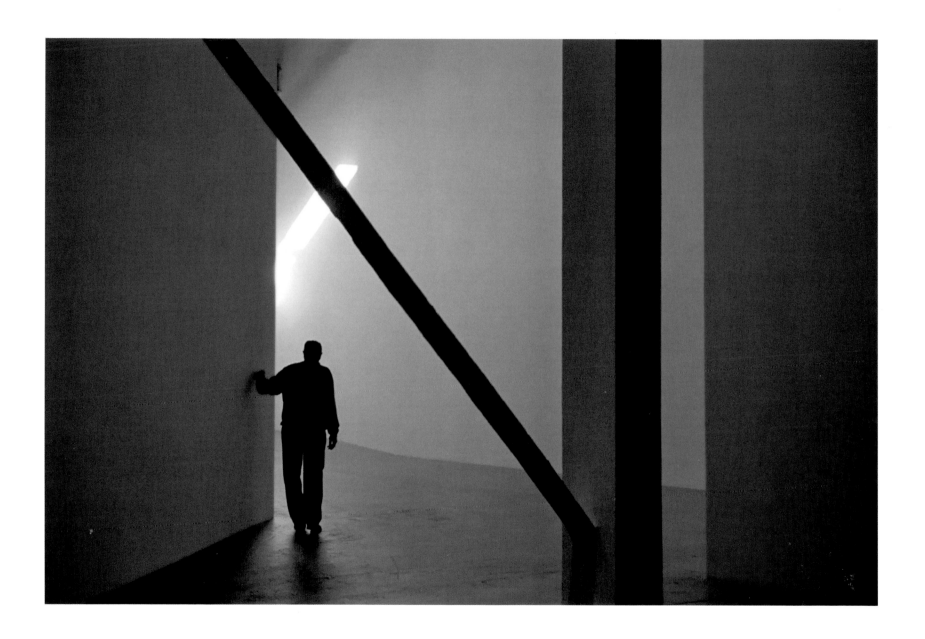

Sometimes Ed doesn't remember that we're married.
Which is something I can deal with.

He never forgets that he loves me and that I love him.
Which is preferable to remembering that we're married
and forgetting that we love each other.

Ed,
I still do...and I always will.

AFTERWORD

We are lonesome animals. We spend all our life trying to be less lonesome. One of our ancient methods is to tell a story begging the listener to say—and to feel— "Yes, that's the way it is, or at least that's the way I feel it. You're not as alone as you thought."

—John Steinbeck

When my husband was diagnosed with Alzheimer's 11 years ago, the stigma and misinformation surrounding the disease added a ponderous weight to our daily challenges. Initially, we felt alone; eventually we found a support group, and were helped by others who were traveling with us on our unwanted journey. We learned from each other's experiences and we were warmed by our connections.

One of the reasons I created this book was to contribute to the discussion we, as individuals and as a society, must have in order to clear the cloud of fear and whispers surrounding Alzheimer's. I am telling my story so that someone else will be more comfortable telling their own.

Photographing the man I love is an intimate process. When I watch Ed through my camera lens, despite the distance of several feet between us, I feel as though I am caressing him. My camera isn't an obstruction, it's another way of touching him.

My photography and writing help me stay sane while the demanding role of caregiver continues to balloon.

As I write this, Ed still lives at home and I'm still his evening caregiver. But I know, someday, I may have to rethink these choices. That's the nature of this monstrous disease—there is no constant, and ambitions and strategies might as well be written in sand.

The mother of the Muses is Mnemosyne, the goddess of memory—and although she ultimately abandoned Ed, she couldn't have sired a more generous and inspirational muse. Ed's support, encouragement, and partnership have resulted in a great gift to me, personally and professionally, but I ache because we can no longer share the results of this special collaboration. Ed's Alzheimer's has progressed to the point where he has severe visual agnosia and his brain no longer makes sense of what his eyes see. Photographs and written words hold no meaning for him. And he's forgotten that we created a book—together.

I'd been thinking about this book for years, but it wasn't easy to come up with a title that properly expressed the relationship Ed and I share. When my daughter asked if there was a special phrase—a personal shorthand or code—that Ed and I used, it was a light-bulb moment. From the moment we were married, he and I told each other daily, "I still do." And—we still do.

ACKNOWLEDGMENTS

There are numerous people who have supported this project and helped propel it forward. But my photographs of Ed might have remained private were it not for the enthusiastic encouragement of Arthur Ollman, the founding director of the Museum of Photographic Arts. Arthur was the first person to see some of these images, and his belief in my work inspired me to begin this amazing journey. Thank you, Arthur, for impacting significantly my work and, therefore, my life.

There have been a number of cheerleaders along the way to whom I'm immensely grateful. Among them are Tim Anderson, Tony Bannon, Brian Braff, Sandy Braff, Susan Burnstine, Charlotte Cotton, Crista Dix, Jeffrey Epstein, Joan Hertz, Sara James, Deborah Klochko, Susan McBeth, Carol McCusker, Jean-Jacques Naudet, Sylvia Plachy, Kirsten Rian, Lisa Snyder, Mary Virginia Swanson, Jennifer Thompson, and my friends in Lisa's group, and head cheerleader par excellence, Jayne Slade. To Joan Brookbank—action-oriented dynamo and friend to artists—thank you for graciously showing *I Still Do* to Daniel Power and for advocating on behalf of my work.

I'm indebted to Daniel, founder and publisher of powerHouse Books, for responding immediately to the project and to Craig Cohen, executive publisher of pH, for making this book a reality and doing so with speed, intelligence, and enthusiasm. Thank you to the warm and wonderful staff of powerHouse Books --including Kiki Bauer, Wes Del Val, Will Luckman, Kate Travers, Jonathan Gelatt, and Sara Rosen. Thank you, Kiki, for designing my book with thought, sensitivity, and respect for my vision.

Aaron Serafino, my computer and design guru, and Jeany Wolf, my publicity coordinator, have been wonderful and supportive additions to the team.

The inclusion of a foreword by the awesome Roy Flukinger is a great honor for any photography book. Roy has done a great deal over the years to champion photography and photographers and I'm pleased to count myself a beneficiary of his benevolence, and a friend.

Kevin Miller, the director of the Southeast Museum of Photography was an early promoter of this project, and his commitment to *I Still Do* means a great deal to me. SMP is making this

work available to a large range of viewers by sponsoring a show and traveling exhibition—I'm both extremely grateful and very touched by the support.

I'm thankful to Helene Lotman and Christine Toretti for their enthusiasm for my book and immediate action on behalf of it. To the Committee of 200—I'm grateful for your order of an abbreviated edition of *I Still Do* to give to the attendees of the 2008 conference; thank you for the vote of confidence. Warm appreciation and gratitude go to fellow C200 member, Senator Kay Bailey Hutchison, for putting my book in the hands of Justice Sandra Day O'Connor. And to the awe-inspiring Justice O'Connor—my deepest gratitude for your lovely words which touched both me and my husband.

A shout-out goes to Carolee Friedlander for introducing me to Sally Susman and Pfizer, Inc. Thanks to Pfizer's gracious support, the reach of *I Still Do* will be greater than I could have dreamed. The people who are working on this project are talented, smart, creative, and truly committed to helping the millions affected by Alzheimer's—I'm grateful to each of you. To the amazing Sally Susman—you're the best. Thank you.

Admiration and gratitude go to Connie Forbes and Ana Paredes who have shown Ed and me a great deal of care and understanding—you're special human beings.

My parents, Harriette and Murray Schneider, were the first people to have confidence in me—I'm thankful to them for passing on to me their love and respect for words; for showering me with all the paper and paint a creative child could want; for letting their pride in me show; and for loving and trusting me. I love and miss them.

To my smart, caring, and creative children, Brian Fox and Jennifer Armour; to my best-in-the-world grandchildren, Hanna and Ian Armour; and to my wonderful son-in-law, Rik—I love you all and I'm very fortunate to have you in my life. I run farther and aim higher knowing you believe in me and want the best for me, as I do for each of you.

And to my spectacular husband, Ed, you've given me the treasured gifts of your love, support, kindness, intelligence, and your partnership in all things, including this book. I owe you so much.

I Still Do
Loving and Living with Alzheimer's

Published in the United States by powerHouse Books,
a division of powerHouse Cultural Entertainment, Inc.
37 Main Street, Brooklyn, NY 11201-1021
telephone 212 604 9074, fax 212 366 5247
e-mail: istilldo@powerHouseBooks.com
website: www.powerHouseBooks.com

First edition, 2009

Library of Congress Control Number: 2009930228

Hardcover ISBN 978-1-57687-507-0

Printing and binding by Asia Pacific Offset

Book design by Kiki Bauer

A complete catalog of powerHouse Books and Limited Editions is available upon request;
please call, write, or visit our website.

10 9 8 7 6 5 4 3 2 1

Printed and bound in China